Texts by LLÀTZER MOIX Photographs by PERE VIVAS

Barcelona
the city of Gaudí

W9-AMA-450

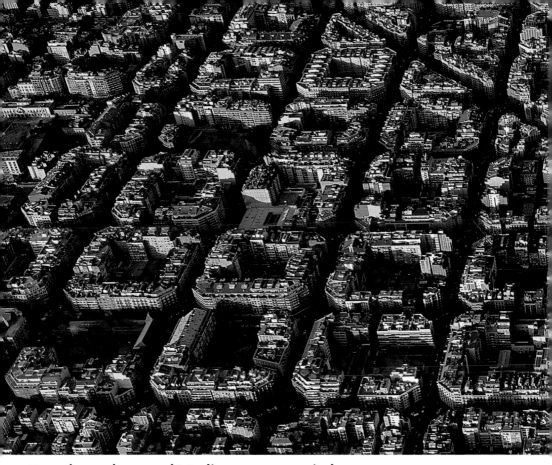

Barcelona, the grand Mediterranean capital, has entered into the third millennium of its history with the appearance and energy of a young debutant. Situated in the northeast Spanish coast, close to France, it carries two thousand years of history on its back and a continuous process of reform. On these lines, the 1992 Olympic Games provided a spectacular general transformation, complemented by the Forum 2004 event, which

Eixample
The orthogonal section designed by Cerdà in the mid-19th century outlines Barcelona's urban planning

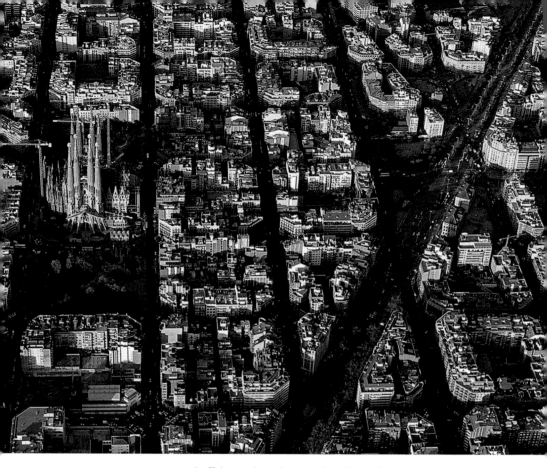

crowned off the work on the coastline. Since then, Barcelona has embarked on the construction of its technological district, the 22@, replacing the outdated industrial link and becoming the base of its new productive identity.

So many transformations have not undermined the traditional attractions of Barcelona, such as an open and welcoming nature, a sunny climate and an average temperature of 17° C, as well as the architectural treasures

and natural setting. Since the dawning of the city, it has been able to coexist with these transformations and turn them into a trait of its character. The Roman colonists founded Barcelona, then Barcino, more than two thousand years ago, in an enclave situated between two rivers, the Llobregat and the Besós, protected by the Collserola range of hills. The strategic position of that first settlement and its potential was already that of a large city. The gentle climate and the abundance of natural resources did the rest: Barcelona became, with the passing of time, the capital of Catalonia. The history of Barcelona goes hand in hand with that of the Catalan region, and the latter, to the history of the Catalan language, one of the offshoots of Latin, and an element that unites the tradition, culture and identity of the country. For this reason one of its golden epochs was in the Middle Ages, when the different domains of Catalan territories came together under the countship of Barcelona, in the shadow of the Frankish kings. That union

Image of the renovated Barcelona coastline. On the left, the two towers of the Olympic Village. On the right, the headquarters of the Gas Natural company

formed the origin of Catalan expansion in the Mediterranean in the 13th and 15th centuries, the stamp of which is still visible in Sicily, Malta or Sardinia, and even in Athens.

After its Roman birth and medieval and Mediterranean youth, Barcelona reached adulthood and prosperity in the mid-19th century with the coming of the industrial revolution and established its position as the Spanish city with the greatest European air; when its walls were knocked down, it grew with the Eixample district, it sprouted new shoots culturally during the *Renaixença* cultural movement and embraced Modernism. In between the 20th and 21st centuries, spurred on by the Olympics, the city has experienced another urban, cultural and economic renewal: Barcelona, which was a Catalan, Mediterranean and European point of reference, is now a global one.

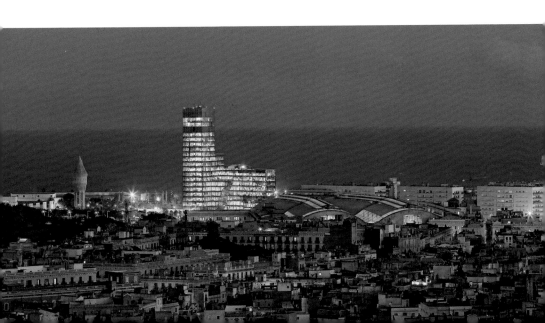

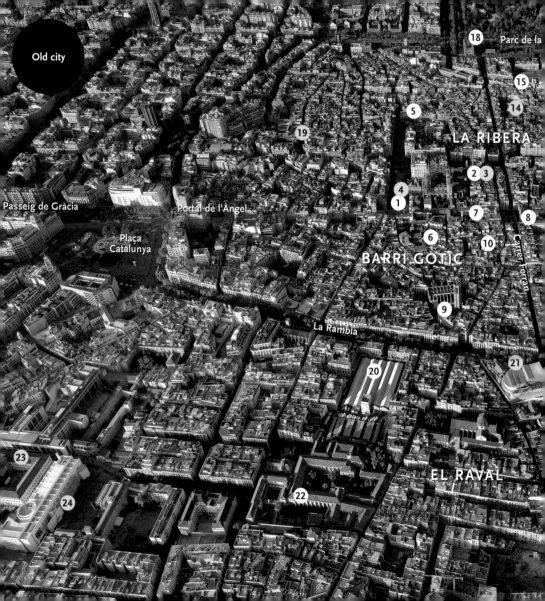

Old city

Parc de la

LA RIBERA

Passeig de Gràcia

Portal de l'Àngel

Plaça
Catalunya

BARRI GÒTIC

Carrer Ferran

La Rambla

EL RAVAL

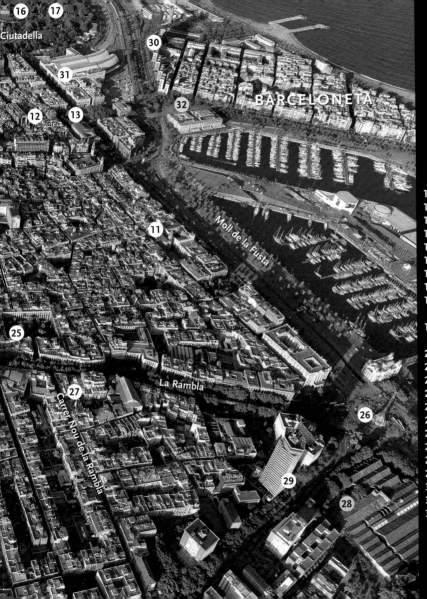

Ciutadella

BARCELONETA

Moll de la Fusta

La Rambla

Carrer Nou de la Rambla

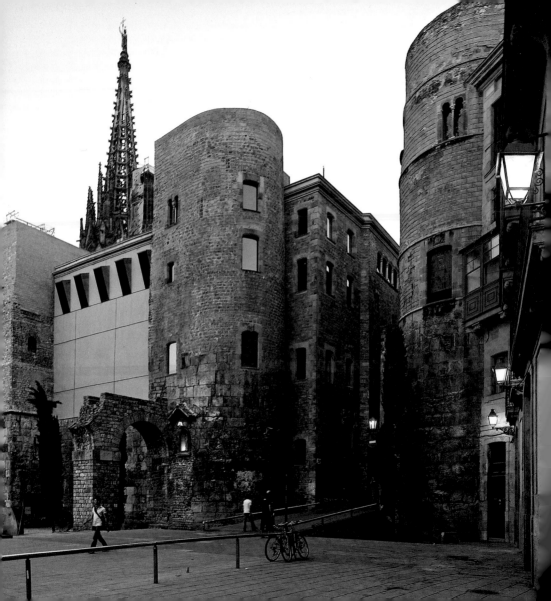

The Roman City

The stamp of Roman civilisation is still present in Barcelona. It is noticeable in the character of the people of Barcelona, more prone to negotiation and agreement regarding commonly accepted rules than reproach and conflict. It is also apparent in its old streets, over which the sediments of its distinct historical periods overlap and combine, as can be seen in the photo on the next page: standing alongside each other, and even in a certain harmony, are the remains of the Roman walls and aqueduct with medieval towers, a Gothic-style cathedral and constructions of more recent centuries and from recent years. Barcelona, like ancient Rome, is more in favour of addition than subtraction.

Barcino was founded shortly before the beginning of the Christian era, in the times of the Emperor Augustus. Its full name was Colonia Iulia Augusta Faventia Paterna Barcino. Other Roman cities in Catalonia, such as Emporion, Gerunda or Tarraco, had greater weight and protection. In fact, Barcino formed part of the Hispania Citerior region, the capital of which was Tarraco. It was Barcino, however, placed on the hill of Mons Taber, and which via a branch of the Via Augusta Roman way, received the call to become the future Catalan capital. Its economic growth and progress were supported from the very beginning. The city was walled in the 4th century, and when the Roman Empire fell apart, the Visigoth king Ataulf, at the turn of the century, turned it into the capital of his domains, which extended through Spain and France.

Roman walls
Remains of the walls,
an aqueduct and
two towers that flank
the entrance to the
Roman city

Barcino, the Roman city.

The visible Roman vestiges in the streets of Barcelona are today limited. In terms of constructions, the most spectacular is made up of four Corinthian columns, with their podium and entablature, belonging to the temple dedicated to Augustus in the city forum, today enveloped in the courtyard of a property in Carrer Paradís, 10. In the Plaça Nova, next to the cathedral, there are remains of one of the aqueducts that supplied the city with water, as well as two semicircular towers, part of the wall, that flanked one of the main entrances to Barcino. This wall, nine metres high and nearly four metres thick, which surrounded the urban precinct of around ten hectares, was strengthened with dozens of towers, most of them square in shape, and it is still partially visible. They were reinforced in the 13th century and restored in some sections in the 20th century. You can follow the construction intermittently from the abovementioned Plaça Nova, and then going along Carrer Tapinería, Plaça

Roman walls
Inscriptions and relief work on one of the sections, still standing, of Barcelona's Roman wall

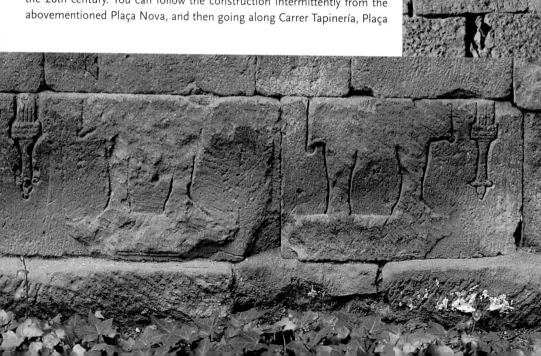

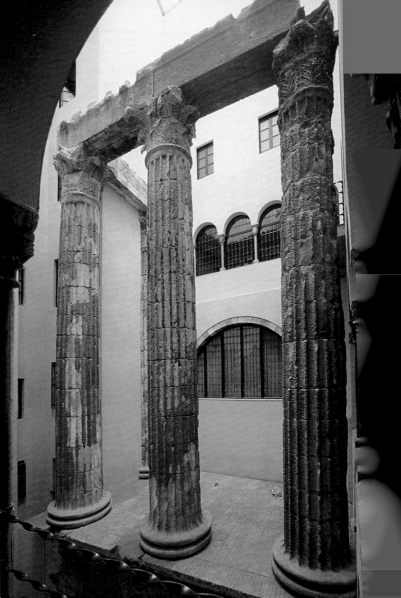

Temple of Augustus
On the right, the four Corinthian columns conserved of the Temple of Augustus

Oil lamp

Ramon Berenguer, and Carrer Sots Tinent Navarro and Carrer Correu Vell, until Regomir, where the opposite gateway opened to that of Plaça Nova. Today's Barcelona still partially conserves sections of the Roman ways Cardo and Decumanus, which divided Barcino into four sectors. However, to get an idea of Roman Barcelona, you should visit the History of the City Museum, in the basement of which, underneath Plaça del Rei, you can visit an archaeological dig that conceals some of the keys to Roman Barcelona.

Historical buildings in the Plaça del Rei
Remains of streets, buildings, columns and sculptures are visible in the archaeological route located underneath Plaça del Rei

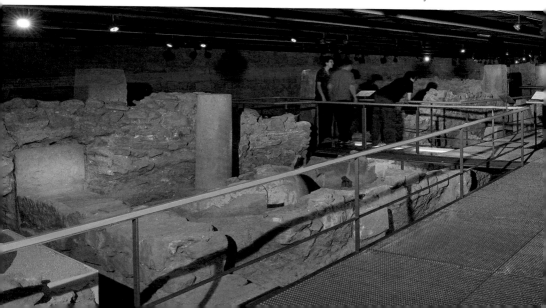

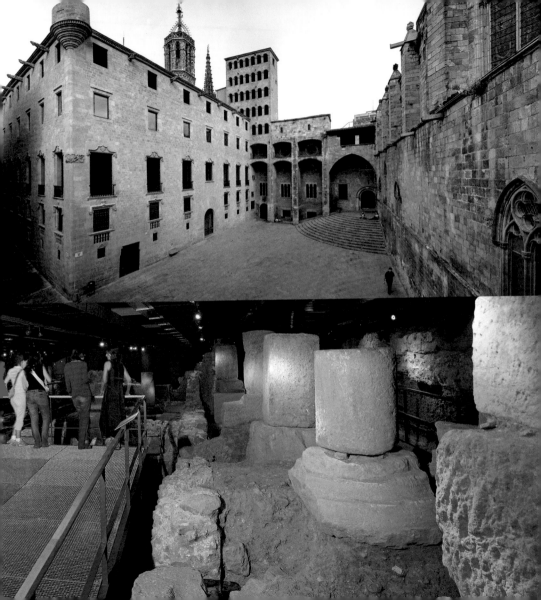

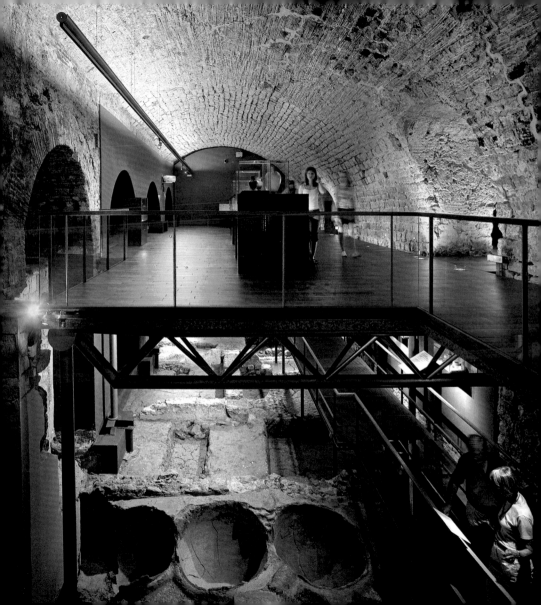

Museu d'Història de Barcelona

MUHBA

Made up of several centres, the Museum of the History of Barcelona (MUHBA) has its main premises in the Casa Padellàs (Plaça del Rei s/n), alongside the series of historical buildings that at one time was the residence of the kings of Catalonia and Aragon. As well as its collections, the MUHBA leads to an underground Roman and archaeological dig measuring 4,000 square metres, with remains dating from the 1st century BC and the 7th century AD. The entrance fee is valid for all the MUHBA centres.

Plaça del Rei, s/n
Tel. 93 315 11 11
www.museuhistoria.
bcn.cat

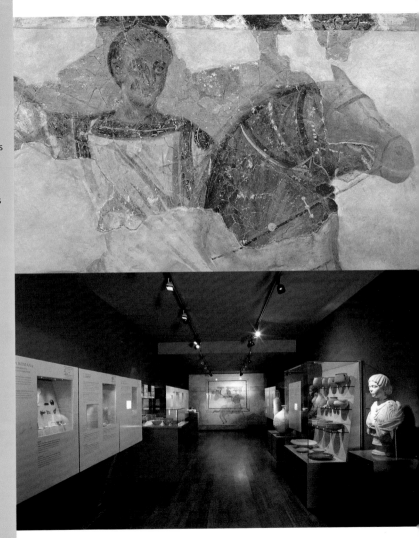

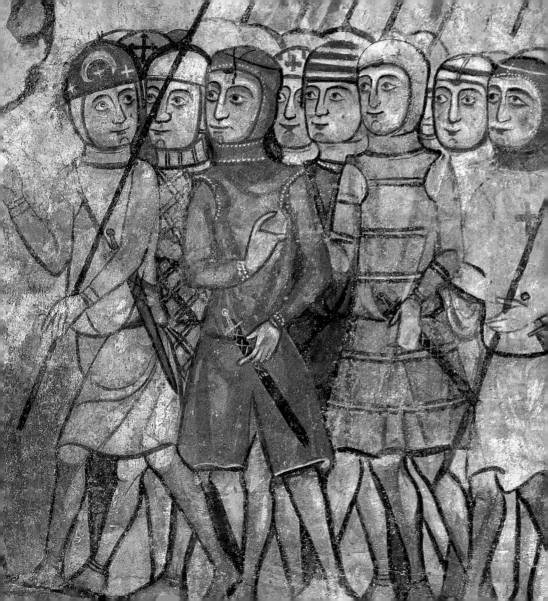

Gothic Quarter

Barcelona is an old tree whose trunk has thickened over two thousand years of history. In the centre of this trunk today is the Gothic Quarter. The streets of this area, situated to the right of the Rambla if walking up from the port towards Plaça de Catalunya, are narrow. As a result, their buildings, with the stamps of time and humidity etched onto their façades, are bathed by a faint and golden light, which touches the pavements for only a few hours a day. This city that dates from an early period, a reflection of the Catalan strength throughout the width and breadth of the Mediterranean world, still preserves a large urban centre, a series of large and extremely impressive historical buildings. Among them feature the city's cathedral and the Palau Reial Major —symbols, respectively, of the religious and worldly powers— still in good conditions of use. Just like the Palau de la Generalitat, the headquarters of the Catalan Government, and the City Hall, home of the city's local authority, as well as the beautiful Gothic churches of Pi or that of Sant Felip Neri, the Mercè or the Gothic church of Pi. Alongside these unique buildings, the Gothic Quarter preserves a centuries-old vitality. This vitality of yesteryear is embodied and sustained by the diverse trade guilds —cobblers, tailors, boilermakers, silversmiths, sail makers, etc.— who worked and lived in its secluded streets, and who on many occasions gave them their names. That vitality is preserved today —and sometimes increased— by the shops, bars, restaurants and hotels situated in its historic buildings, as well as a constant flow of foreign visitors.

Paintings in the Tinell Hall
Detail of the 14th-century fresco, which represents a military parade of the Catalan armed forces

Gothic Quarter.

A Basic route around the Gothic Quarter could begin in the Plaça Nova —an open pedestrian area— facing the cathedral of Barcelona, one of the large series of historical buildings in the area. The other is the Palau Reial Major, which is reached via Carrer del Bisbe and passing outside the cathedral apse via Carrer Pietat, towards the Plaça del Rei. The Palau Reial Major, which overlooks this square, the seat of Catalan power in its medieval age of splendour, has been built, enlarged, mutilated or restored since the end of the Roman Empire. Particularly impressive on reaching the square is the palace façade and the Renaissance stairway at the entrance. The façade, made up of different sequences of arches that crown the Rei Martí tower, is large and spectacular, and conceals the Saló del Tinell (the main hall), where it is said that Christopher Columbus discussed his voyage to the West Indies with the Catholic Monarchs. The Palau Reial Major is surrounded, to the left, by the Palau del Lloctinent, and to the right by the beautiful and simple chapel of Santa Àgata. On the

Tinell Hall
The semicircular diaphragm arches characterise the magnificent architecture of the Tinell Hall

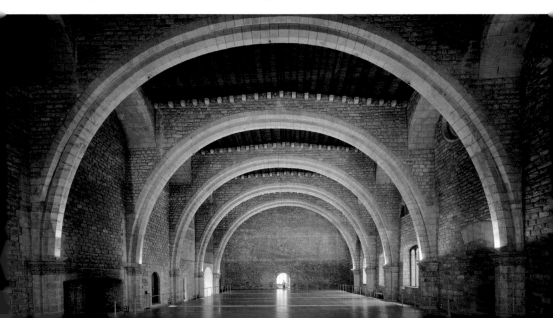

Wall in Plaça Ramon Berenguer
Constructed parts of the wall, at the height of Ramon Berenguer and, behind then, the Palau Reial and the cathedral

fourth side of the square, alongside a modern iron sculpture by Eduardo Chillida whose forms harmonise with the medieval architecture, is the Casa Padellàs. Underneath the square, and fitted out to be visited, is the Roman archaeological dig which is entered via the History of the City Museum, described in the previous chapter. These remains extend beneath other buildings, such as the Marès Museum, whose courtyard is a haven of peace in this colourful urban fabric, as is the Plaça de Sant Felip Neri, as well as the other hidden corners of the district.

A short distance from the Plaça del Rei is the Plaça de Sant Jaume. In this area of italianized taste the two great administrative powers based in Barcelona face each other: that of the Generalitat, the autonomous Catalan Government, whose palace stands on one side of the square, and that of the City Council, whose building stands on the other. The Palau de la Generalitat is a construction whose early parts date back to the beginning of the 15th century. Its most outstanding elements, the courtyard and the

main stairway, the façade in Carrer del Bisbe or the Pati dels Tarongers courtyard, are sections built according to Gothic styles. Its main façade, facing Plaça de Sant Jaume, is in Renaissance style. The City Hall is also a building that has experienced successive transformations. Its most outstanding part is the Saló de Cent, where the representatives of the people met as far back as the late-14th century, and which continues today as the main hall of the city council. The central space of Plaça de Sant Jaume, flanked by both institutions, is the setting for all kinds of demonstrations, whether patriotic, or for the protests by diverse groups, or celebrations of great sporting victories... The route around the Gothic Quarter can be continued returning by Carrer del Bisbe (and going under the bridge that joins the Generalitat with the official residence of its President) until Plaça Nova, and from there, along Carrer de la Palla, reaching the church of Pi and ending the tour.

Trades in the cathedral
In the cathedral area relief work and inscriptions are conserved in memory of the medieval trades

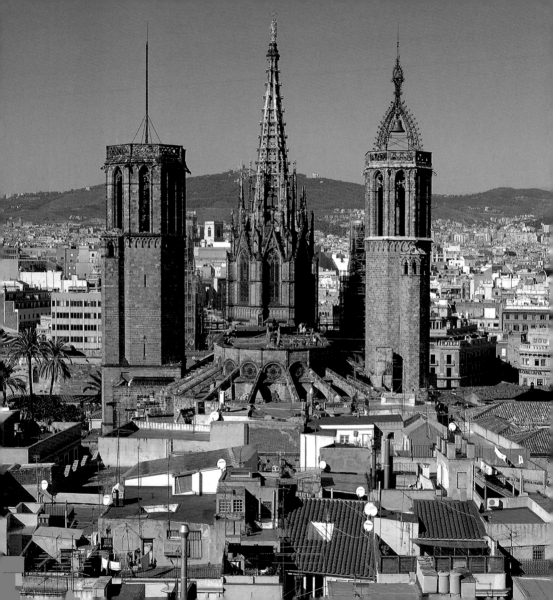

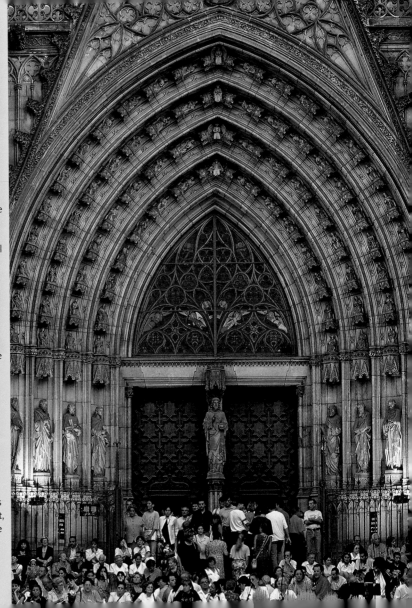

Cathedral

The Gothic cathedral of Barcelona as it stands today began to be built at the end of the 13th century and continued in construction until six centuries later, when at the end of the 19th century its façade was completed. The temple has three naves with cross-vaulting and is flanked by two graceful octagonal towers. You should visit the cloister attached to the cathedral, where magnolias, loquats, palms and orange trees grow. These features, as well as the arches, the complex wrought iron gates, the flickering wax and candle shop of the chapels and votive offerings, the geese that live there, the murmur of the water and the moss that carpets the hundreds-of-years-old flagstones beneath a filtered light, together create a quite unique atmosphere.

Tel. 93 15 10 05
www.catedralbcn.org

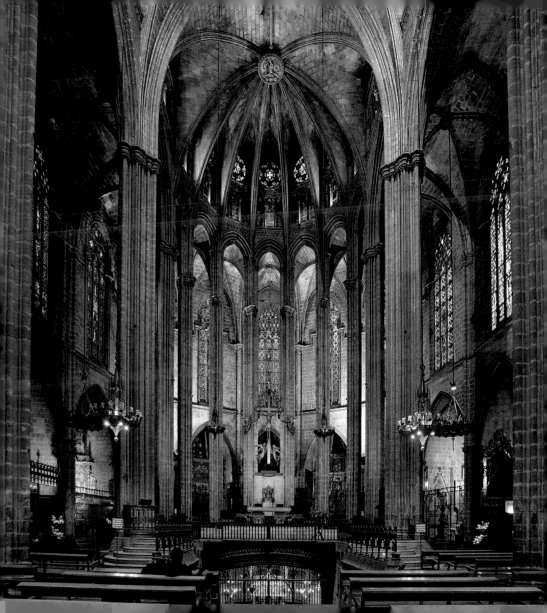

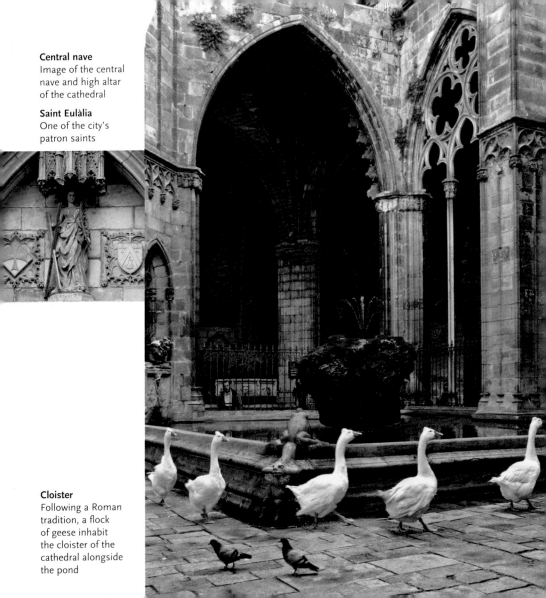

Central nave
Image of the central nave and high altar of the cathedral

Saint Eulàlia
One of the city's patron saints

Cloister
Following a Roman tradition, a flock of geese inhabit the cloister of the cathedral alongside the pond

Carrer del Bisbe
Bridge of flamboyant Gothic style, but dated in 1928, in Carrer del Bisbe

Sant Felip Neri
On the right, Plaça de Sant Felip Neri, a pleasant and isolated spot close to the cathedral

Gothic relief work
Detail of two pieces of relief work, in Carrer del Bisbe and Sant Felip Neri

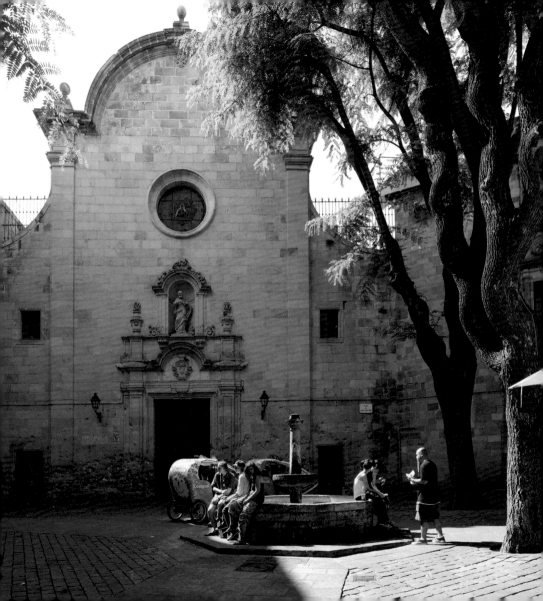

**Palau de
la Generalitat**
On the right, the
Renaissance façade
of the Palau de
la Generalitat,
headquarters of the
Autonomous Catalan
Government, in Plaça
Sant Jaume, in the
heart of old Barcelona,
very close to where
Barcino, the Roman
city, was. In the image
on the left, detail of the
Pati dels Tarongers,
dated in the 16th
century, one of
the characteristic
precincts of the Palau
de la Generalitat

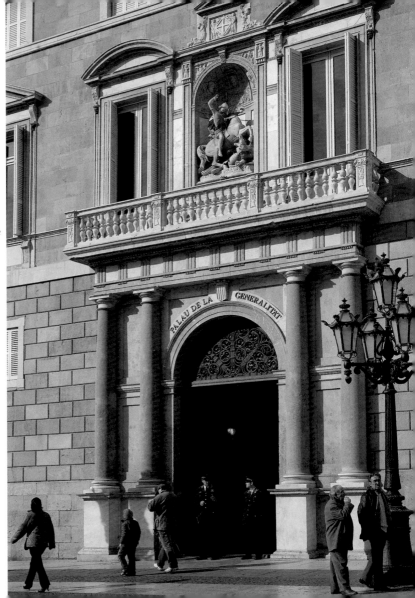

Sculpted portraits
Decorative corbels that represent several states, ages or ethnic groups, on the Gothic façade of the Palau de la Generalitat

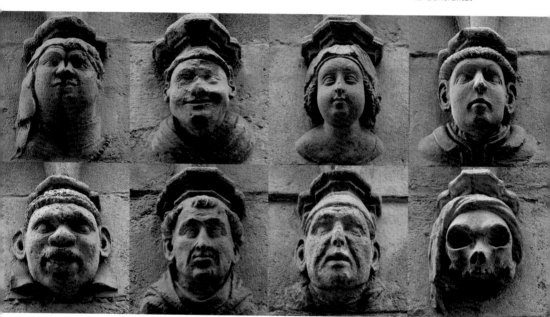

Saint George
Figure of the patron saint of Catalonia, battling with the dragon, on the wall of the Generalitat that leads to Carrer del Bisbe

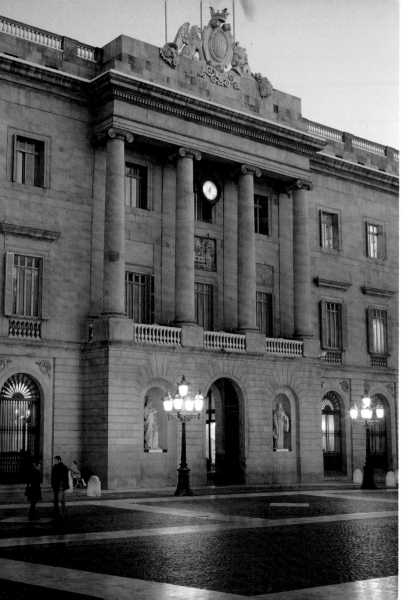

Barcelona City Hall
On the left, neo-classical façade of Barcelona City Hall, in Plaça Sant Jaume, opposite the headquarters of the Generalitat

Saló de Cent
For centuries the future of Barcelona was decided by the Consell de Cent (Council of one hundred), an assembly of "honourable citizens" who held their meetings in the Saló de Cent. This austere and majestic chamber is characterised by its semicircular diaphragm arches, and is still used by the City Council as the best venue for its special acts

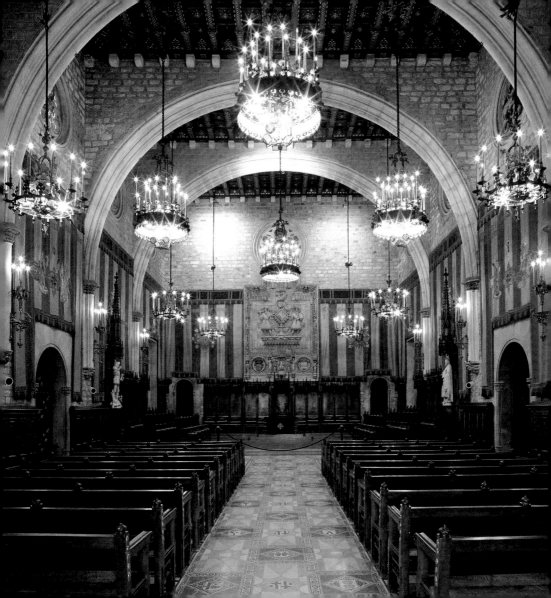

Gargoyles
Four gargoyles placed
on the building of the
City Hall, on its façade
in Carrer Ciutat

**Shield on the
Sant Miquel doorway**
Sculptural detail
referring to Jaume I
on the old municipal
Gothic façade

Church of Pi
Temple started in the 14th century, with a square façade, large rose window and imposing octagonal bell tower, over 50 metres high

Plaça del Pi
Image of one of the traditional shops in the square

Palau Moxó
Sgraffito of the façade

Fivaller Fountain
La Fivaller (15th century), in Plaça Sant Just i Pastor, was the first public fountain of running water in the city

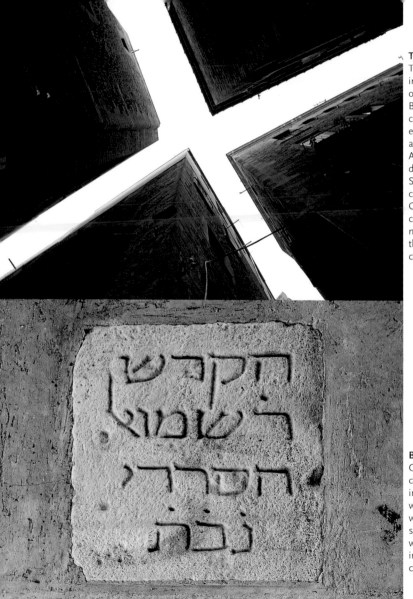

The Jewish Call
The Jewish tombstone in the photo below is one of the vestiges of Barcelona's Hebrew community, which experienced its golden age during the Middle Ages, settled in the district of the Call. Some of the main cultural centres in Catalan lands were concentrated in its narrow streets between the 14th and 15th centuries

Basílica of the Mercè
On the right, the church of the Mercè, in Baroque style and with a single nave, where the patron saint of Barcelona is worshiped, and whose image crowns the cupola of this temple

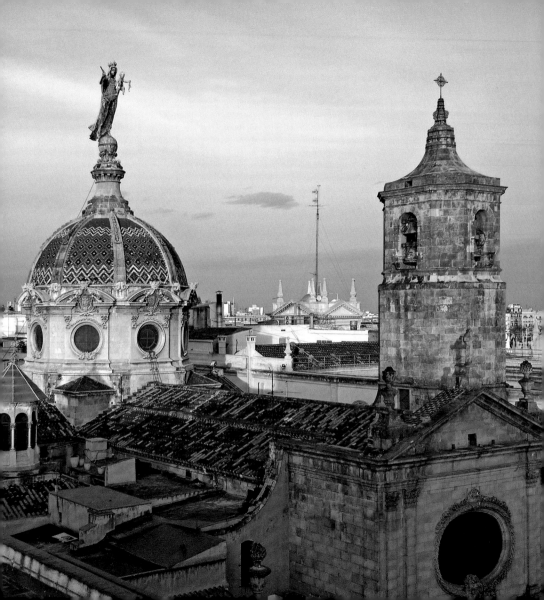

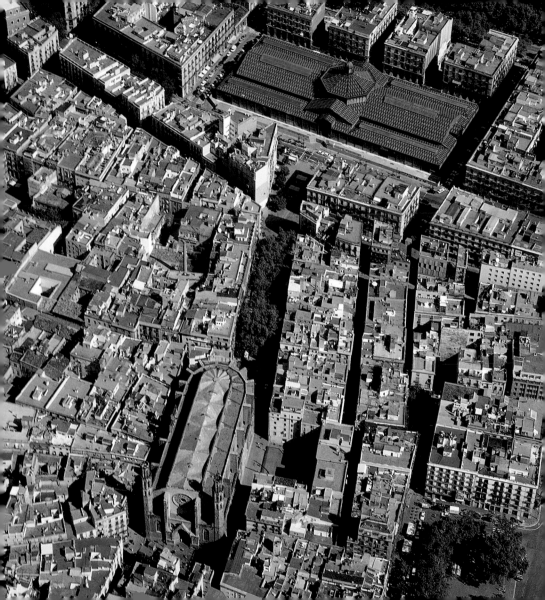

The Ribera

Barcelona was founded alongside the sea. And by the sea, The Ribera, hustling and bustling with tourism, conserves its extremely old urban layout. Overlooking the district is the church of Santa Maria del Mar, a building by Berenguer de Montagut and a paradigm of the best Catalan Gothic, built quickly and with a purity of lines from the first half of the 14th century. Its interior, organised in three very high naves, is majestic and elegant, both in terms of the slenderness of the columns and for the distance separating them. Santa Maria del Mar overlooks and organises The Ribera. Passing along narrow streets, starting from its façade, we reach the Llotja, with a beautiful Gothic interior and neo-classical exterior. In the opposite direction, starting off from the apse of Santa Maria and turning left, we go down Carrer Montcada, with a succession of splendid medieval residences, entered by high portals suitable for horses and carriages, with spacious courtyards surrounded by a stairway leading to the main floor. These overelaborate large houses are today occupied by museums, such as the Picasso Museum, galleries and shops. Also starting from the apse of Santa Maria del Mar is the Passeig del Born, which takes the same name as the old supplies market, a powerful metallic structure, which today houses an eighteenth-century archaeological site. Further on from the Born is the Parc de la Ciutadella, named after the old military fortress, the site of which is today occupied by the park's green spaces, fountains and small lake, the Catalan Parliament building, diverse museums, such as the Natural Science Museum, and the Zoo.

La Ribera
The temple of Santa
Maria del Mar and the
Born market overlook
the district of La Ribera

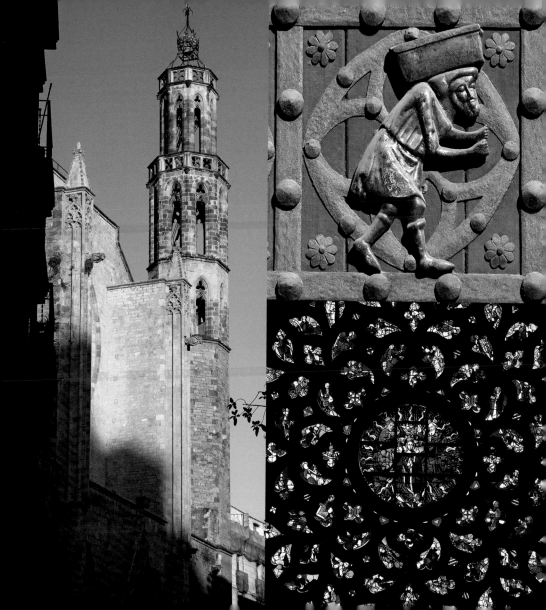

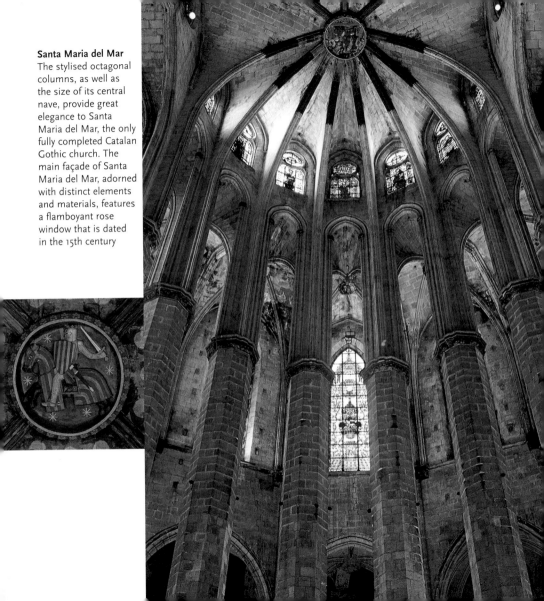

Santa Maria del Mar
The stylised octagonal columns, as well as the size of its central nave, provide great elegance to Santa Maria del Mar, the only fully completed Catalan Gothic church. The main façade of Santa Maria del Mar, adorned with distinct elements and materials, features a flamboyant rose window that is dated in the 15th century

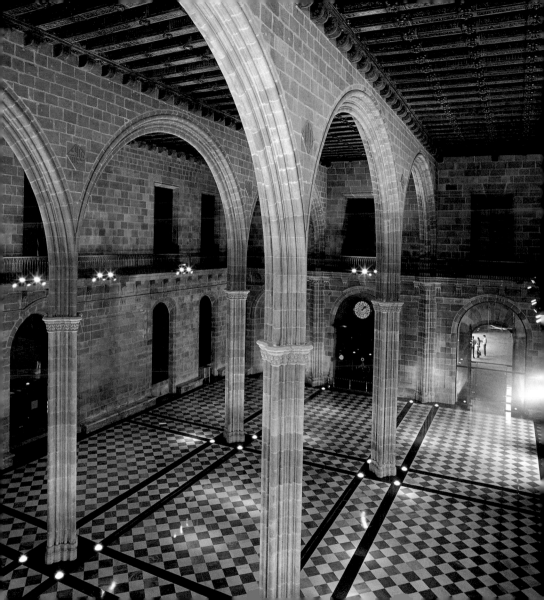

Llotja de Mar
The Gothic hall of the Llotja de Mar, the trading exchange, built at the end of the 14th century as a space for commercial transactions, was covered to neo-classical tastes in the 18th century, and has housed diverse activities, ranging from a fine arts school to the Stock Exchange

Barbier-Müller Museum
Courtyard of the museum of pre-Columbine art situated in a palace in Carrer Montcada

Palau Dalmases
Construction with Baroque ornamentation in Carrer Montcada, with its courtyard and stairway that leads to the main floor

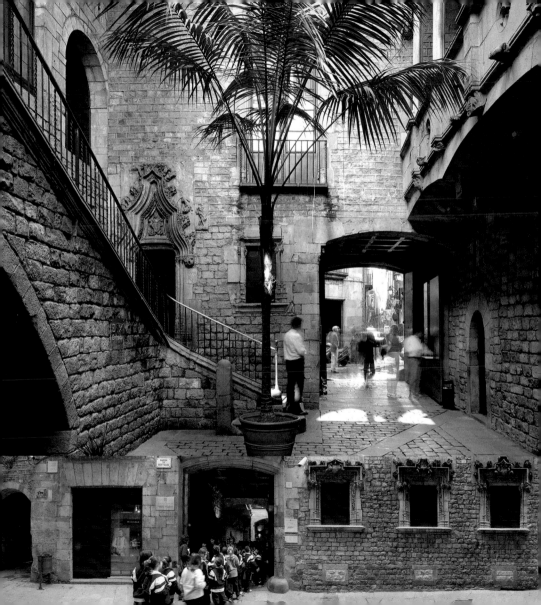

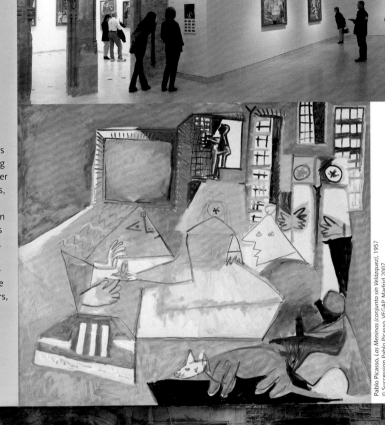

Picasso Museum

In five interconnected palaces in Carrer Montcada, the main thoroughfare of medieval Barcelona, the Picasso Museum houses the best collection from the artist's formative years and some outstanding paintings from his later periods. His paintings, in which successive artistic revolutions can often be discerned, as well as the renovated, open-plan halls, contrast with the age-old atmosphere of the museum headquarters, one of the principle cultural attractions of Barcelona.

c/ Montcada, 15-23
Tel. 93 256 30 00
www.museupicasso.
bcn.cat

Pablo Picasso, *Las Meninas (conjunto sin Velázquez)*, 1957
© Succession Pablo Picasso, VEGAP, Madrid 2007

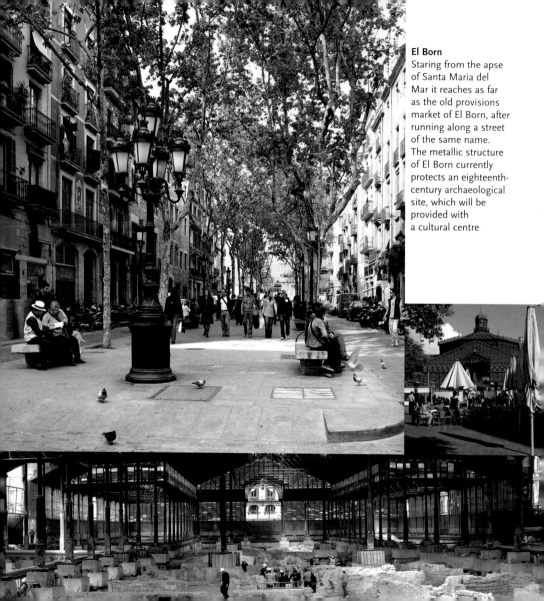

El Born

Staring from the apse of Santa Maria del Mar it reaches as far as the old provisions market of El Born, after running along a street of the same name. The metallic structure of El Born currently protects an eighteenth-century archaeological site, which will be provided with a cultural centre

Ciutadella Park

The park is made up of a stretch of land formerly occupied by the military fortress of the same name. The top photo shows the park's fountains and waterfall, the work of Josep Fontserè on which Gaudí assisted as a student. Below, detail of the park's mammoth, a vestige of the Universal Exhibition of 1888

Catalan Parliament

Façade of the building that houses the Catalan Parliament. In the foreground, "Desconsol", by Josep Llimona

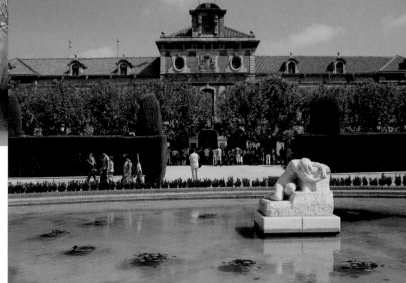

Barcelona Zoo

One hundred years ago, the Barcelona Zoo was built on 13 hectares of Ciutadella Park. It contains some 7,500 animals belonging to 400 species. Future plans are for a new zoo to be built in the Forum area

Natural Science Museum

Located in a stunning building designed by Domènech i Montaner in the 19th century, the old Zoology Museum, now joined with the Geology Museum to form the Natural Science Museum, houses important collections, among which feature those of the vertebrates, coleopteran and molluscs

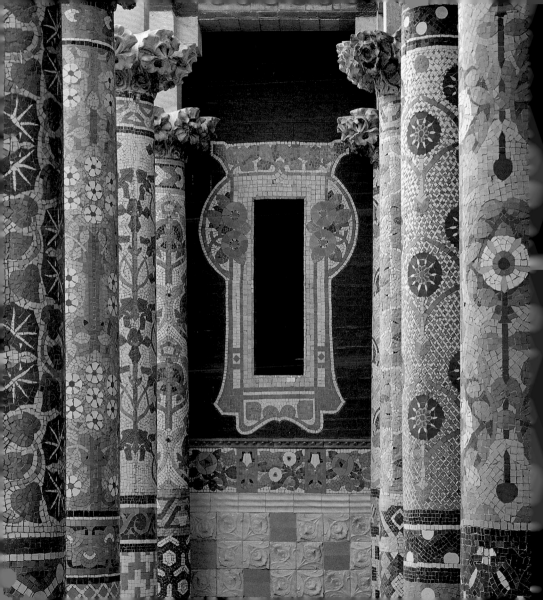

Palau de la Música Catalana

Modernism possesses one of its major works in the Palau de la Música Catalana. This exuberantly ornamented redbrick building, the work of Lluís Domènech i Montaner, was built between 1905 and 1908. Its interior boasts a unique and astonishing concert hall. Designed with total expressive freedom, despite the narrowness of the site, the Palau is a polychrome, floral, magical and welcoming space, which schedules hundreds of concerts each year and which has been recently enlarged.

c/ del Palau de la Música, 4-6
Tel. 93 295 72 00
www.palaumusica.org

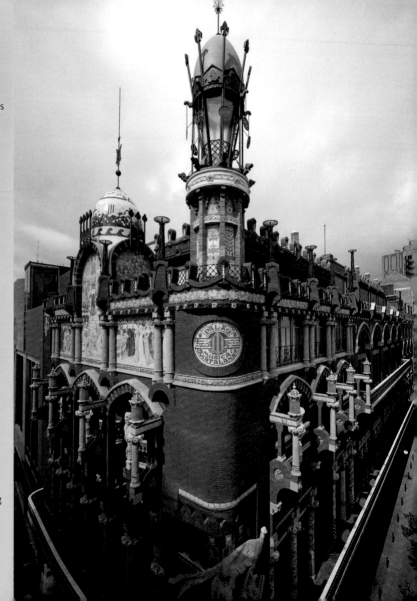

Skylight
The stalls of the
Palau de la Música
are covered by a
spectacular and
multicoloured skylight

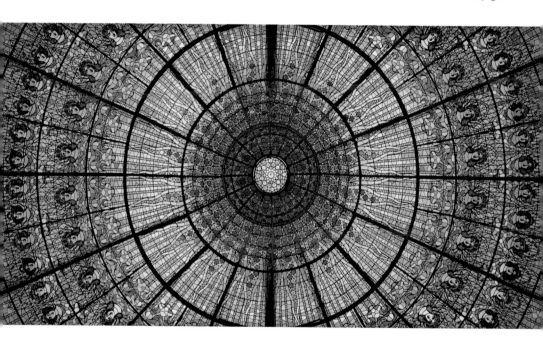

Hall
The hall of the
Palau de la Música is
in itself a symphony
of Modernist
craftsmanship

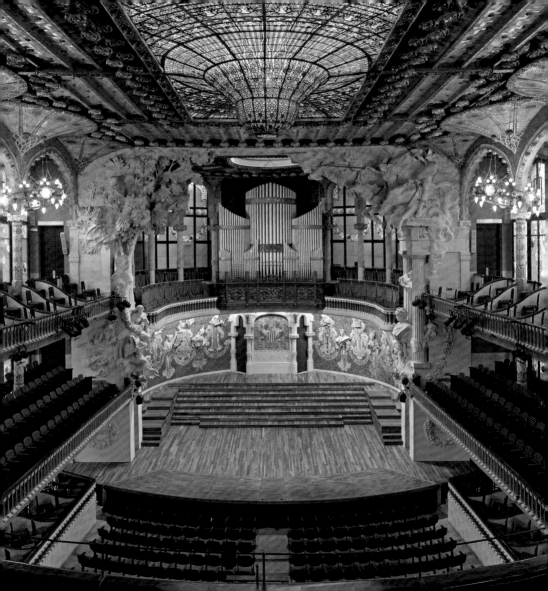

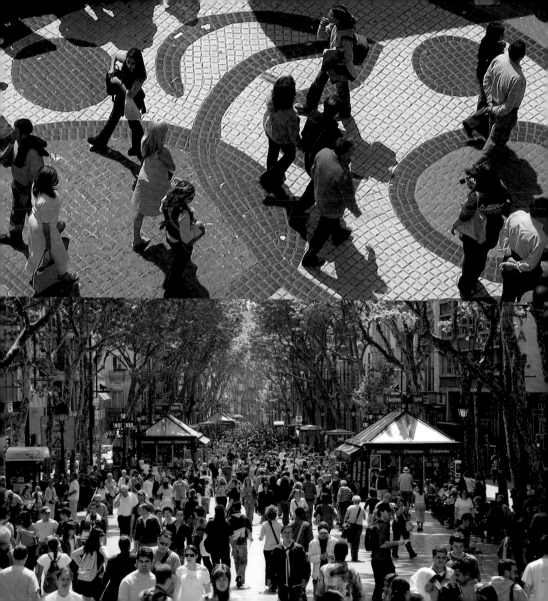

The Rambla and the Raval

The Rambla is the liveliest and most vibrant street in Barcelona. Down its central walkway, the Barcelona locals stroll towards the sea, and foreign visitors blend into the palette of colours, aromas and sound of the city. The Rambla is the beautiful and very busy symbol of an open city, in which cultures and ethnic backgrounds are all mixed. This is particularly true of the old district of the Raval, to the right of the Rambla (if going downhill), where recently built museums stand alongside the medieval Library of Catalonia or Romanesque churches... For centuries the Rambla was an open torrent which flowed through Barcelona into the sea. Today it is a street shaded by leafy plane trees, which separates the Raval from the Gothic Quarter. Organised around a spacious central pedestrian zone, the Rambla is an explosion of life, punctuated by terraces and bars and newsstands, flower stands and pet shops. It is also occupied by residents, tourists, human statues, artists, poets, rogues and those with time on their hands: all human life in all its shapes and forms converges on the Rambla... Whoever walks down it starting from Plaça de Catalunya will see the church of Pi sticking out (through a gap built into a modern building), step on a mosaic created by Joan Miró and be able to enter the Boqueria Market. The stained-glass windows of its portico are a foretaste of the rich colours of the stalls on display under its roof. Passing the Liceu theatre, to the left the Plaça Real opens up, a space with arcades and palm trees; and further on, the Rambla widens our before the Centre d'Art Santa Mònica and ends at the feet of the Columbus monument, alongside the waters of the Mediterranean.

The Rambla
Two typical images of the Rambla: passers-by walk over a mosaic by Miró, and beneath the springtime plane trees

→
Human statues, artists and flower and pet stalls give the Rambla atmosphere

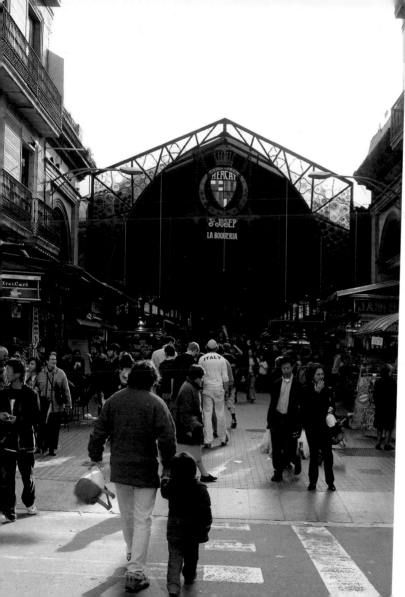

**Sant Joseph market
"La Boqueria"**
Situated alongside
the Rambla, the
Sant Joseph market,
popularly known as
"La Boqueria", is
the best and most
varied assortment
of fresh foodstuffs
in Barcelona. It is
sheltered beneath
a large metallic
structure, and offers
its gastronomic
treasures in a shady
and fresh atmosphere,
particularly lively and
colourful

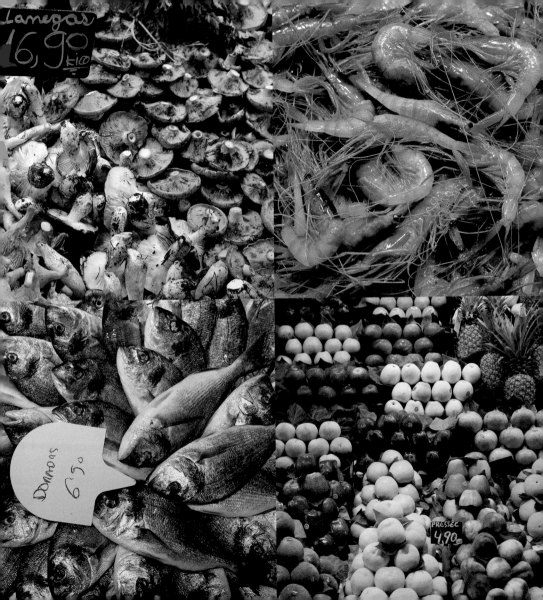

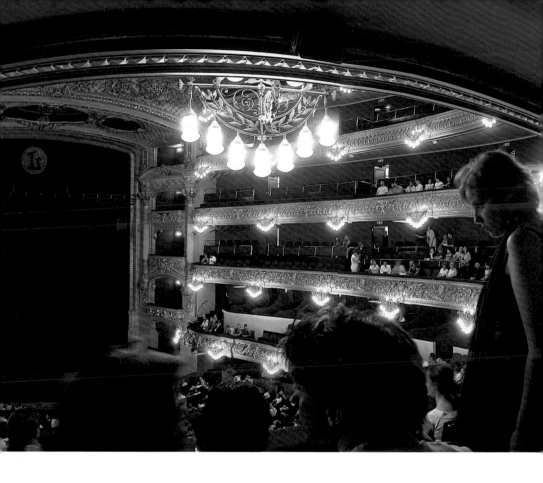

Gran Teatre del Liceu

Opera has its Barcelona home in the Gran Teatre del Liceu, which has stood in the Rambla since 1847. Since that time the Liceu has fed Barcelona's love for opera, in the past passionately divided between Wagnerians and lovers of Verdi. This coliseum has suffered two fires, one in 1861, and the other in 1994, which destroyed the theatre completely, being rebuilt, enlarged and reopened in 1999. Now it puts on 125 performances each year and has more than 20,000 subscribers.

La Rambla, 51-59
Tel. 93 485 99 00
www.liceubarcelona.com

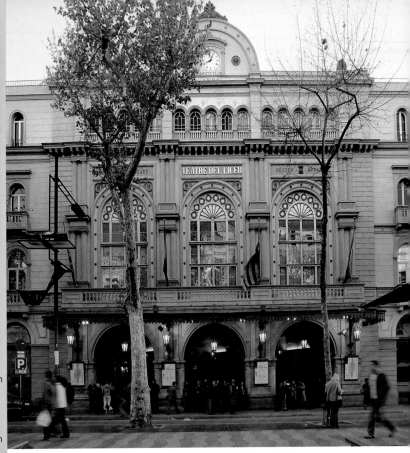

Sant Pau del Camp
Temple of millenary origins, whose current construction dates back to the 12th century

Library of Catalonia
One of the Gothic halls of the Library of Catalonia, in the old hospital of La Santa Creu

El Raval
The renovation of the Raval has enabled the recent opening up of a spacious Rambla. This district is home to traditional commerce along with others that reflect its current ethnic and cultural diversity

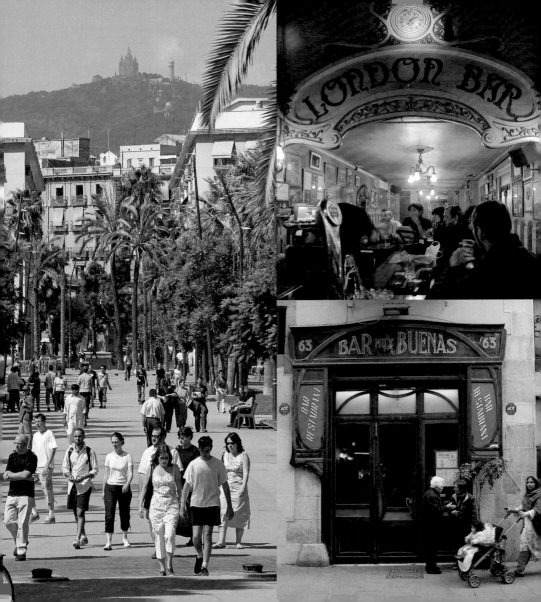

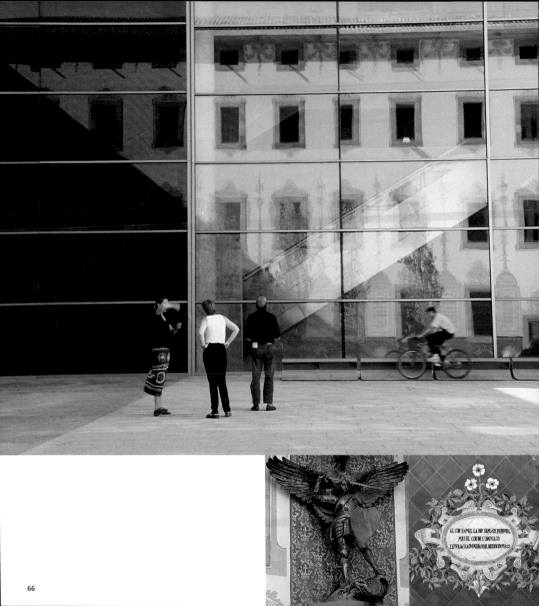

Centre de Cultura Contemporània de Barcelona
CCCB

The Centre of Contemporary Culture of Barcelona was opened in 1994 as an innovative, multidisciplinary cultural institution, in which cities, the various expressions of urban coexistence, were to play a leading role. This idea of coexistence can be seen clearly in the CCCB building, where the old installations of the Casa de la Caritat are combined with the impressive glass cube, the work of Viaplana/Piñón. This idea is further shown in a wide-ranging programme of the centre's own exhibitions.

c/ Montalegre, 5
Tel. 93 306 41 00
www.cccb.cat

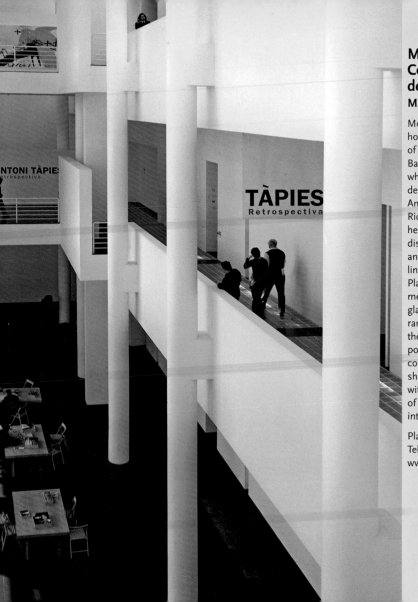

Museu d'Art Contemporani de Barcelona
MACBA

Modern art has its home in the Museum of Contemporary Art of Barcelona (Macba), a white, luminous block, designed by the North American architect Richard Meier in the heart of the Raval district. The museum and gallery, which is linked to the lively Plaça dels Àngels by means of an immense glazed atrium, has ramps which lead to the different floors, possesses its own art collection, regularly sharing the space with the creations of contemporary international artists.

Plaça dels Àngels, 1
Tel. 93 412 08 10
www.macba.es

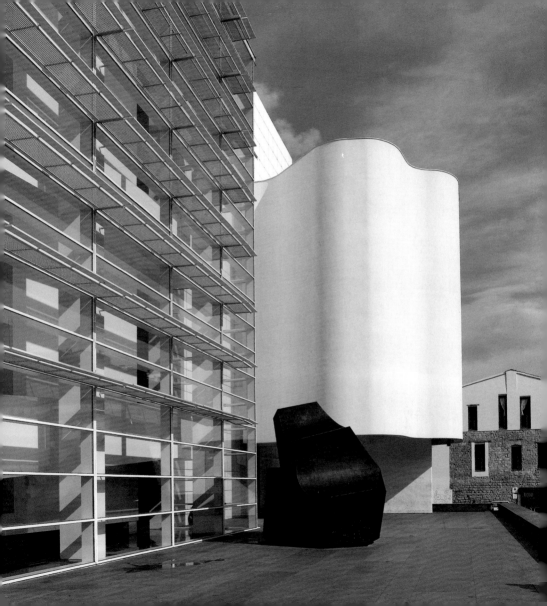

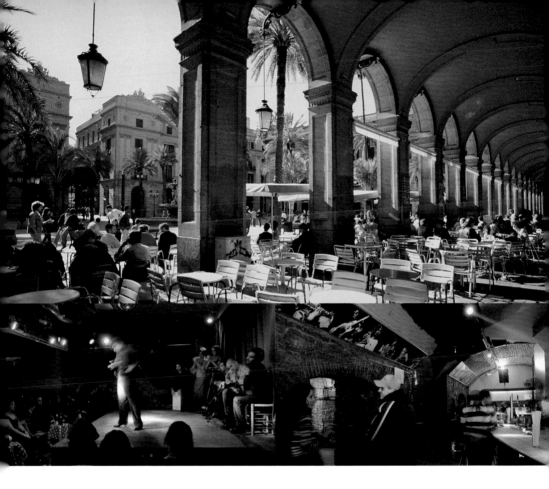

Plaça Reial
Characterised by its arcades and palm trees, Plaça Reial, along with the Ramblas, houses diverse hotels and restaurants, as well as music and dance venues, among them Los Tarantos (flamenco) and Jamboree (jazz)

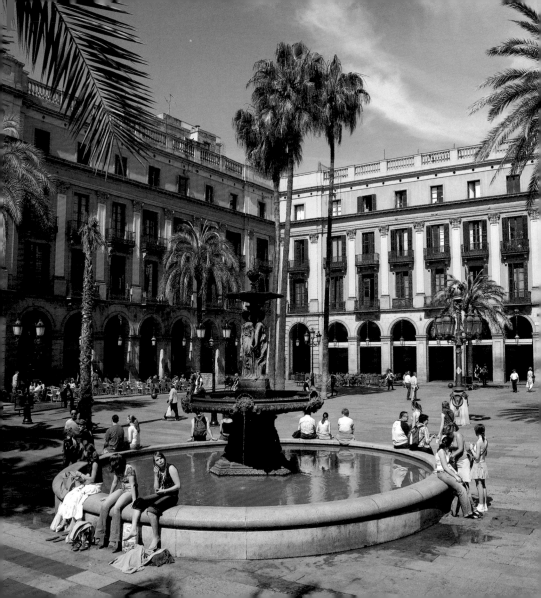

Rambla de Santa Mònica

On the next page, four details of the lower section of the Ramblas: the monument to the writer Pitarra, the Centre d'Art Santa Mònica, a shop with a nineteenth-century feel and one of the lions that flank the monument to Christopher Columbus

Monument to Columbus

50 metres high, over a column fitted out with a lift and viewpoint, the discoverer of America points to the new continent and marks the arrival of the Rambla to the sea

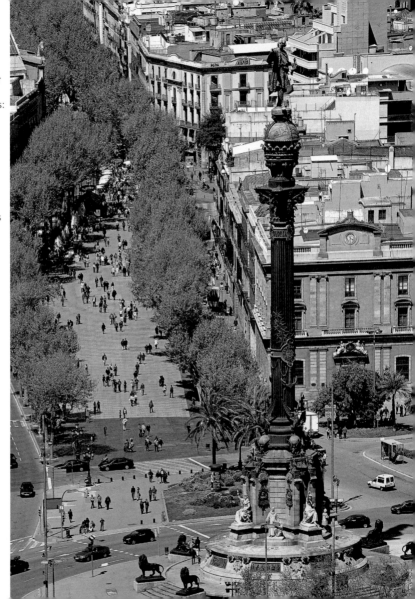

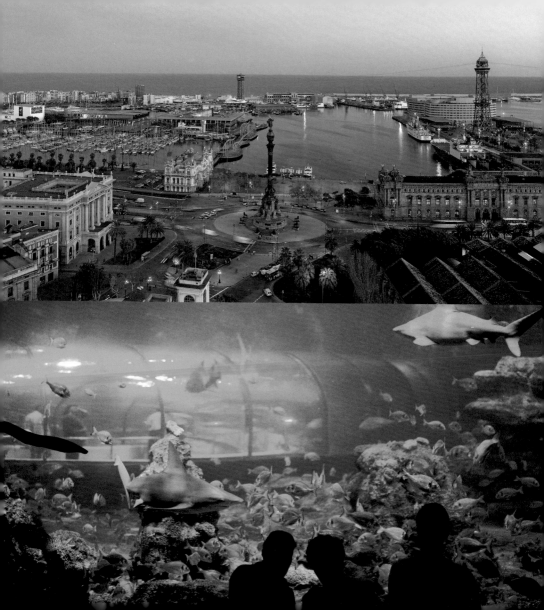

The port and the coastline

Christopher Columbus, 50 metres up at the top of one of the most well-known monuments in Barcelona, points permanently out to sea with his index finger. In this sense, Columbus personifies the debt of gratitude that Barcelona owes the sea, by which some of the founders of Barcino arrived, and by which their descendents travelled to relate with the rest of the world. At Columbus's feet unfolds the Moll de la Fusta, which leads to the Port Vell. What in the past was a succession of wharves occupied by fishermen, dockers and sailors, to which were moored fishing and cargo boats, today is an area dedicated to leisure where, alongside the jetties of the sports marina, the Nautical Club and the maritime port, the World Trade Center has been built, an enormous complex of offices and, in the central area, the Maremàgnum. It is a small leisure city built over the port's waters and joined to the land by a sinuous raised walkway, a genuine floating extension of the Rambla. Restaurants, bars, Imax cinemas and a huge aquarium, in which species from all the seas are kept, complete the scene at this much-visited area, where the public can renew their connection with the sea. It is also where they can board the *golondrinas*, typical leisure boats that sail the waters around the port; or fly over this blue sheet on one of the compartments of the cable car, which links the Barceloneta district with the Montjuïc mountain.

Port Vell
The central area of the Barcelona port, with its lamina of water and, to the left, its sports area

L'Aquàrium
Species from all the seas share the space of the Aquarium of Barcelona, situated in the port

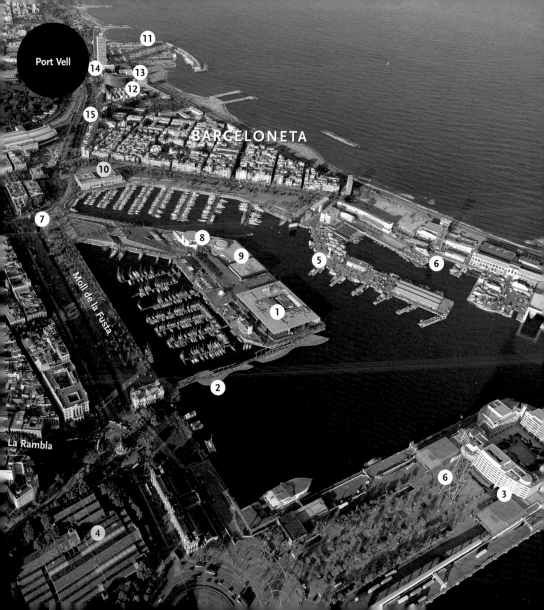

Port Vell

BARCELONETA

Moll de la Fusta

La Rambla

Port Vell. Barcelona is a port city that has been able to turn its port into a relaxation and leisure area, without, however, abandoning its traditional functions that are undertaken on the seashore. A stroll along the Barcelona coastline, the central part of which is occupied by Port Vell, shows you that the links between the Mediterranean and the city today cover the most diverse activities. From south to north, the first place is the large commercial port, with its silos and warehouses, with its piles of containers, which supply or unload the goods to and from the cargo ships. A long breakwater protects this port, the last shelter for the city from the sea and the favourite spot for fisherman with their rods, long-distance runners, cyclists and sweethearts. It is on the dock that closes this breakwater where the large cruiser boats moor, making Barcelona one of their most desired Mediterranean ports of call, and where several terminals have been built to make room for the tourist arriving by sea. Closer to Columbus is the maritime

station for the scheduled shipping lines that link Barcelona with destinations in the Balearic Isles: Mallorca, Menorca and Eivissa.

Beyond Port Vell, the World Trade Center and Maremagnum, the walker will come across Barceloneta, a fishermen's district of narrow streets in which you can breathe in the sea air, where there are loads of restaurants specialising in paellas, fish dishes and seafood. And next to Barceloneta, occupying some large, former goods warehouses, stands the History of Catalonia Museum. The whole of Barceloneta faces the sea and the beach, which extends for four kilometres between the breakwater of the commercial port and the Forum area. This series of beaches is only briefly interrupted when reaching the Olympic Village, which has its own sports marina, which has yachts anchored in the waters facing the city. Straight after, though, all along this recently built district, is Barcelona's new seafront, built to house the athletes who took part in the 1992 Olympics, and

Port Vell from the sea, with the maritime station, the World Trade Center and the sports and fishing jetties

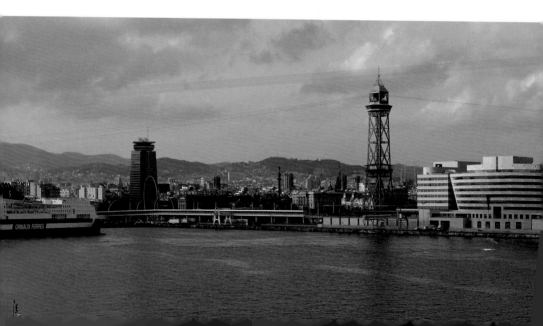

today one of the most dynamic parts of the city, formally characterised by its open brickwork constructions that recall the old industrial nature of this part of Barcelona. The stretch of beach also continues, occupied all through the year by sun-seekers, until it reaches the Forum area, the setting for a big international event organised by Barcelona in 2004 in favour of dialogue, peace and sustainability.

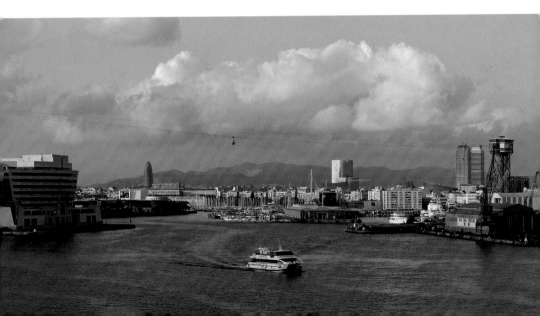

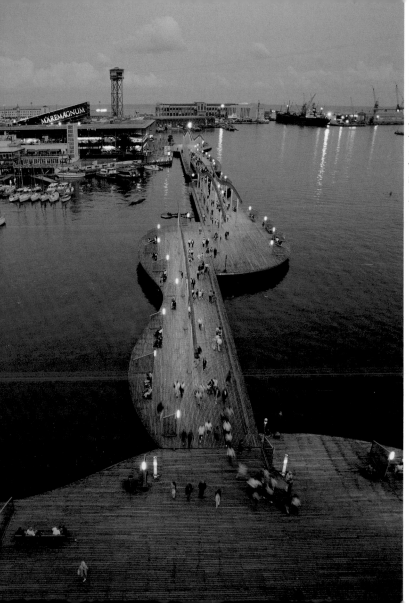

Rambla de Mar
His floating walkway briefly extends the Rambla as far as the Maremagnum area

World Trade Center
This office building, situated over the waters of the port, gives a new aspect to Barcelona's maritime façade

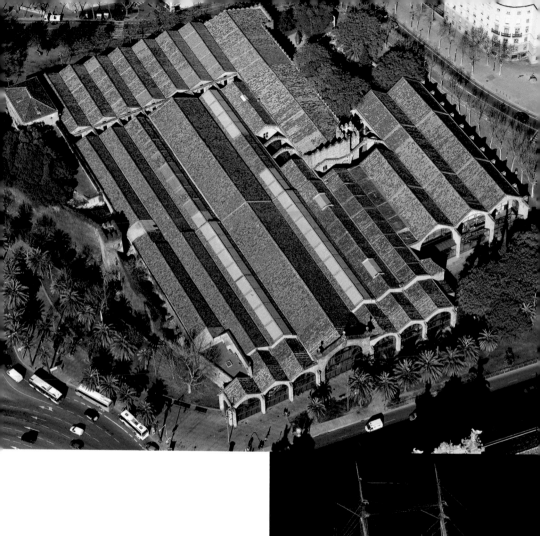

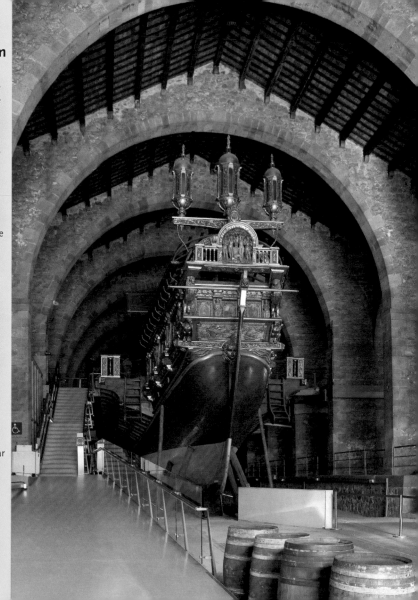

Museu Marítim

Les Reials Drassanes, home to the Maritime Museum, are massive shipyards, whose early installations, built in the 14th century, enabled thirty galleys to be built at the same time. The building is made up of a collection of simple stone naves, constituting one of the great achievements of Gothic civil architecture, perfectly preserved. Inside there are boats from different periods on exhibit, such as the galley of John of Austria. Entrance to the Maritime Museum, open every day from 8 a.m. to 8 p.m. is 6 euros.

Av. Drassanes, s/n
Tel. 93 342 99 20
www.museumaritimbar
celona.cat

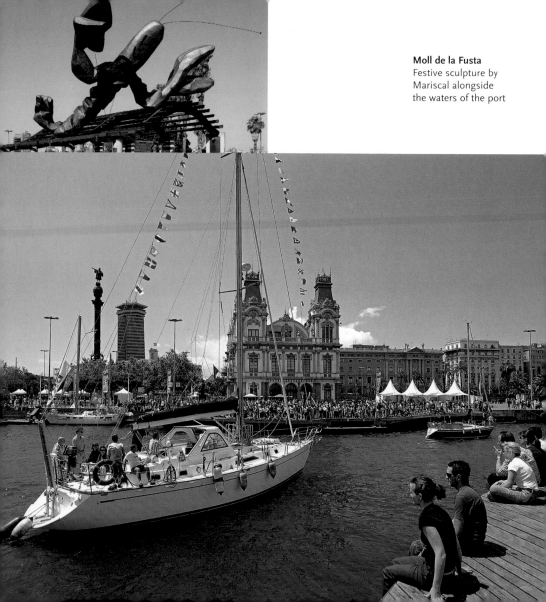

Moll de la Fusta
Festive sculpture by
Mariscal alongside
the waters of the port

Clock tower
This construction overlooks Barcelona's fishing jetties

Montjuïc Cable Car
This cable car flies over the waters of the port

"Barcelona Head"
Sculpture by Roy Lichtenstein opposite Port Vell

Cine Imax
The leisure facilities of Maremàgnum has one of its big attractions here

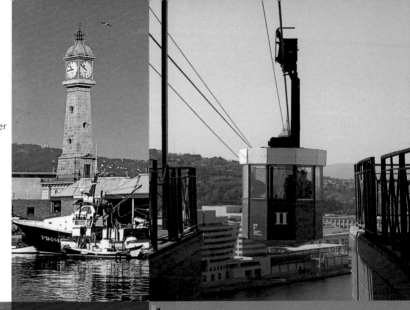

A *golondrina*, pleasure boat

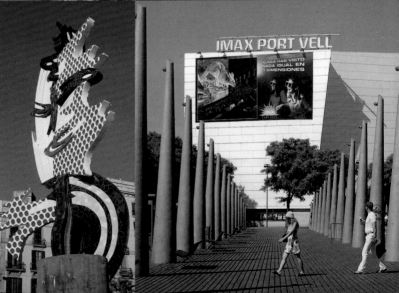

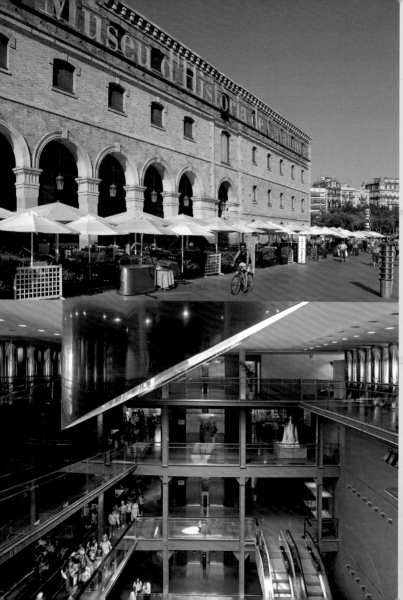

Museu d'Història de Catalunya

Situated in the Palau del Mar, the History of Catalonia Museum (MHC) was opened in 1996 to show and disseminate Catalan history, with the specific aim of strengthening national identity. Its permanent exhibition, which is complemented by temporary ones, covers the evolution of Catalonia, from Palaeolithic times through to the recovery of democratic freedom and autonomous institutions, in the last quarter of the 20th century. Entrance to the museum, open every day, is 3 euros.

Plaça Pau Vila, 3
Tel. 93 225 47 00
www.mhcat.net

Barceloneta

The old fishermen's district, with a very popular atmosphere. Its beach, on which stands a spectacular work by Rebecca Horn, L'estel ferit, is one of the busiest of Barcelona. The many restaurants in this area of the city specialise in rice dishes, fish and seafood

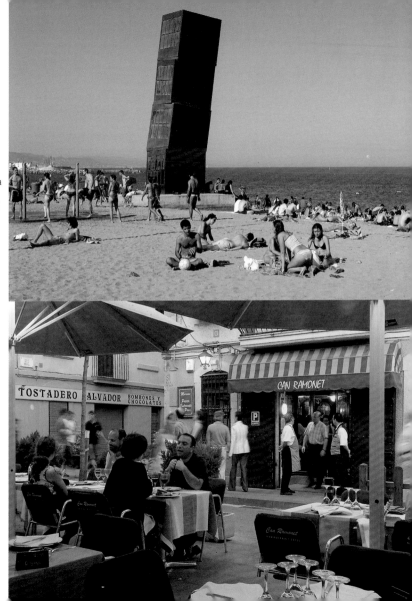

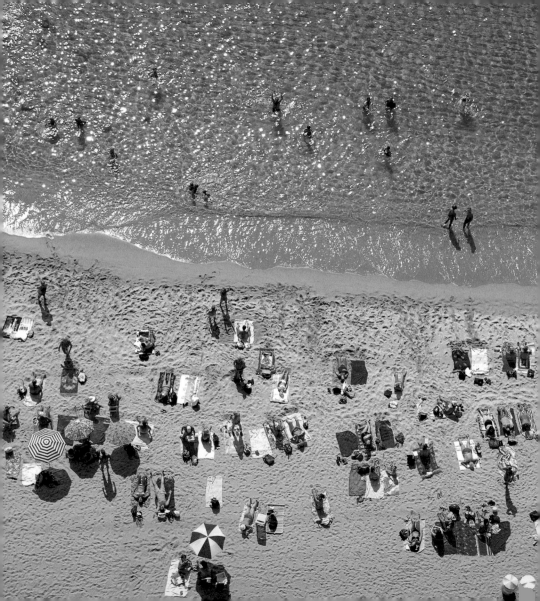

Beaches

The relationship that Barcelona has with the sea has grown exponentially due to the different reforms undertaken for the Olympic Games. Barcelona's seafront is a long beach only interrupted by the sports port of the Olympic Village. The people of Barcelona enjoy the sun and the sea of their beaches throughout the year

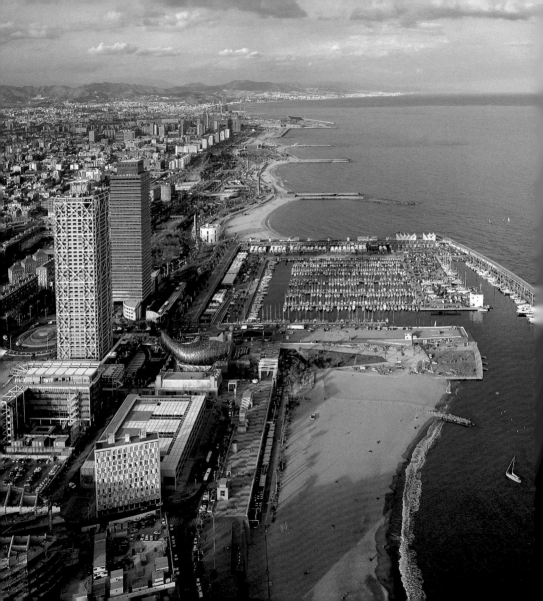

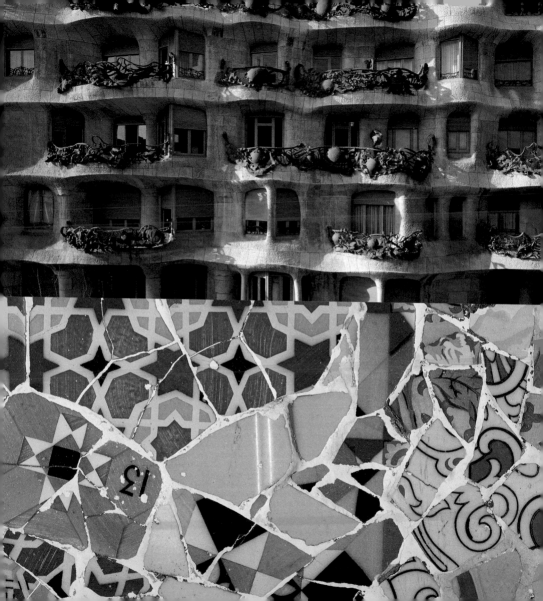

The city of Gaudí

The image of Barcelona is associated with that of the architect Antoni Gaudí (Reus, 1852-Barcelona, 1926): discovering his work is the number one priority for many visitors to the city. The architecture features among the main attractions of Barcelona, where there are remains of the Roman city and a Gothic Quarter in very good condition; where the splendour of Modernism shines out and where in the last few decades buildings have gone up —and continue to be built— designed by some of the most famous architects in the world. But if you had to choose a single name as an emblem of Barcelona's singular architecture, that name would undoubtedly be Gaudí. The great works of this genius inspired by nature and boundless imagination —under which are concealed innovative structural solutions— are concentrated in Barcelona. To a large extent, this is due the patronage of the industrialist Eusebi Güell, a regular client of the architect. From spectacular residential buildings such as Casa Batlló or La Pedrera to temples such as the Sagrada Família, as well as Park Güell, Gaudí's major works appear in Barcelona. And they are not the only ones: as well as the abovementioned works, the city contains other examples of Gaudí's talent, such as Casa Vicens, the Pavilions of the Güell Estate, Palau Güell, Casa Calvet, the Theresan College or the Bellesguard Tower. Moreover, very close to Barcelona, the Gaudian route can be completed with a visit to Santa Coloma de Cervelló, to the sensational and very expressive crypt of the Colònia Güell industrial village, finished in 1915.

La Pedrera
In the heart of Eixample stands this masterpiece by Gaudí

Trencadís
Catalan word for ceramic collage, often present in Gaudí's

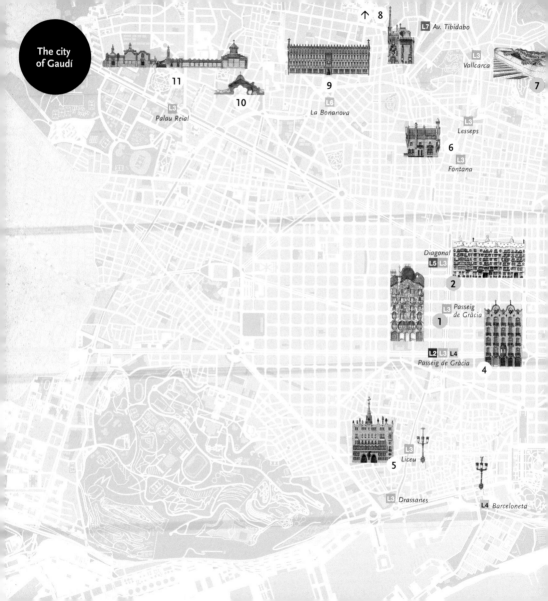

The city of Gaudí

8 ↑

L7 Av. Tibidabo

L3 Vallcarca

7

11

10

9

L3 Palau Reial

L6 La Bonanova

L3 Lesseps

6

L3 Fontana

Diagonal
L5 **L3**

2

L3 Passeig de Gràcia

1

L2 **L3** **L4**
Passeig de Gràcia

4

5

L3 Liceu

L3 Drassanes

L4 Barceloneta

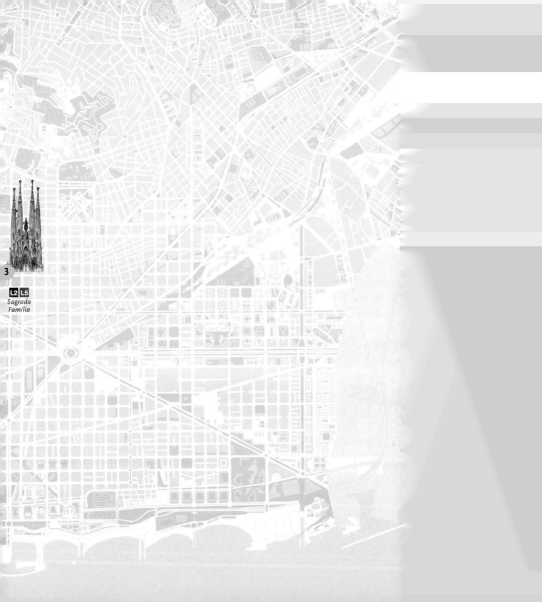

3

L2 L5
*Sagrada
Família*

Casa Batlló.

Casa Batlló has its origins in the total reform of a building that was already standing. Gaudí was given the task of remodelling this house at Passeig de Gràcia, 43, and he did it conscientiously. Adding two floors, he rebuilt the first floor and totally removed the outer layer of the property, achieving a colourist and personal architectural style, free of all historical points of reference. Curved lines dominate the façade, adorned with elements of organic forms —which remind one of bones, plants, saurians— or artificial forms —masks— and with a texture that recalls brocades and precious stones. The roof has the appearance of the scaly back of a dragon, and is crowned by a bulbous cross and several chimneys. The skylight, with its watery chromatic gradation, from blue to white, makes full use of the light available, and the interior decoration is dominated by rounded forms in a Modernist style.

Desk area of Casa Batlló with its characteristic curved forms and ceramic wall coverings

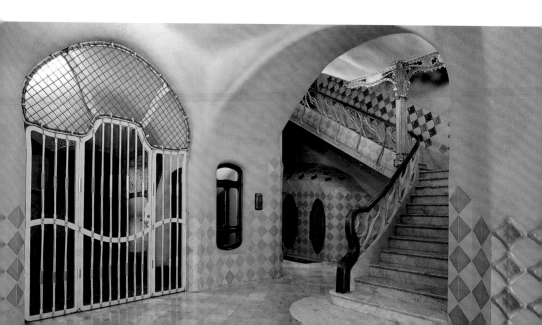

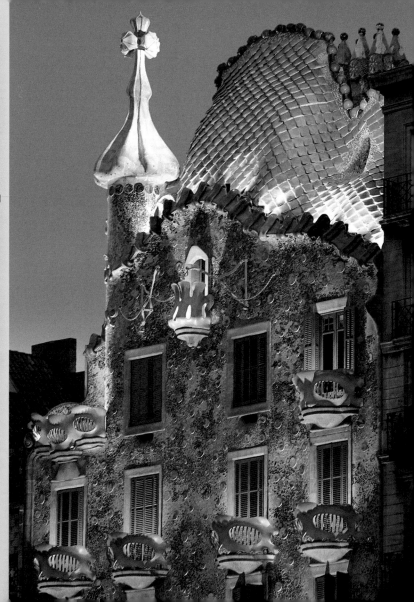

Casa Batlló

Casa Batlló is open to visitors seven days a week between 9 a.m. and 8 p.m. and comprises a tour of the first floor, attic and terrace. Casa Batlló has some rooms that can be rented for professional meetings or private celebrations. It also has a shop.

Passeig de Gràcia, 43
Tel. 93 216 03 06
www.casabatllo.cat

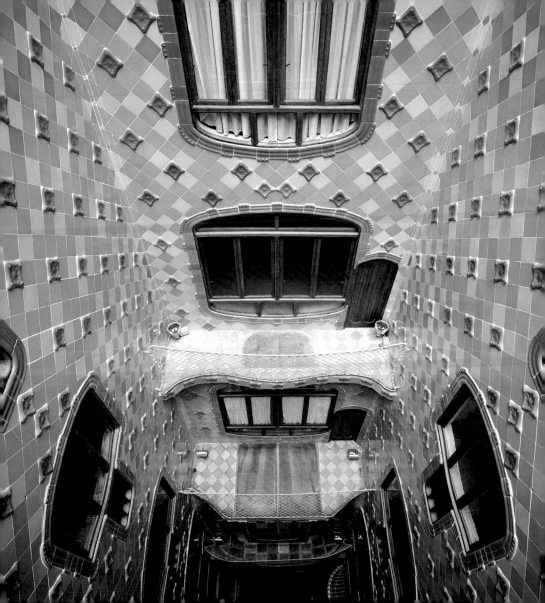

Skylight
The chromatic gradation enables maximum use of natural light

Roof
The roof of Casa Batlló recalls the scaly skin of a giant saurian

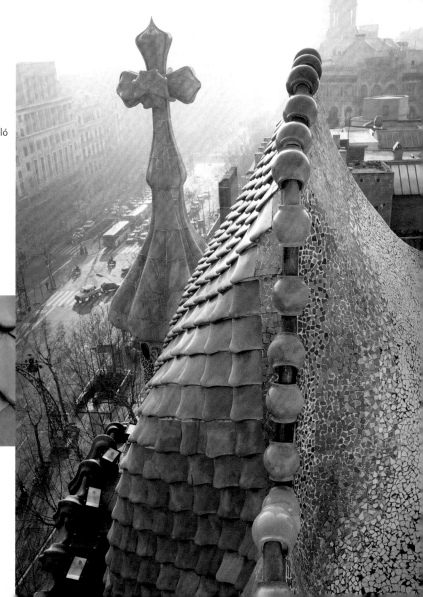

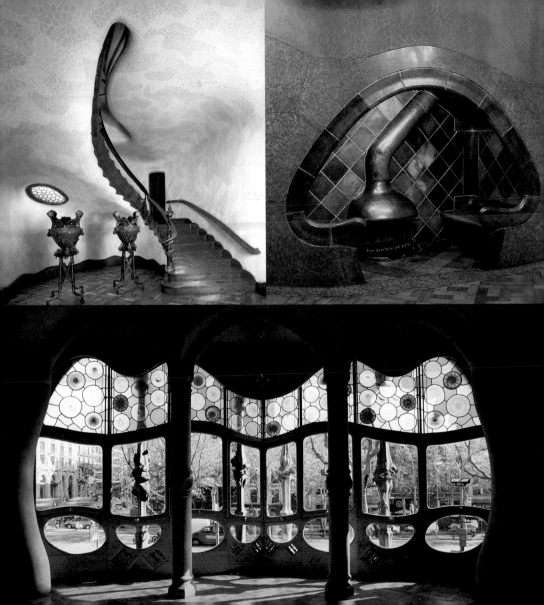

Stairway
Modernist expression defines the stairway to the main floor

Hearth
The hearth offers a cosy corner, with two benches by the fireplace

Gallery
Sinuous forms of stone and coloured glass in the gallery

Façade
Details of the ceramic and glass ornamentation of the façade

Attic
The parabolic arches support the structure of the attic

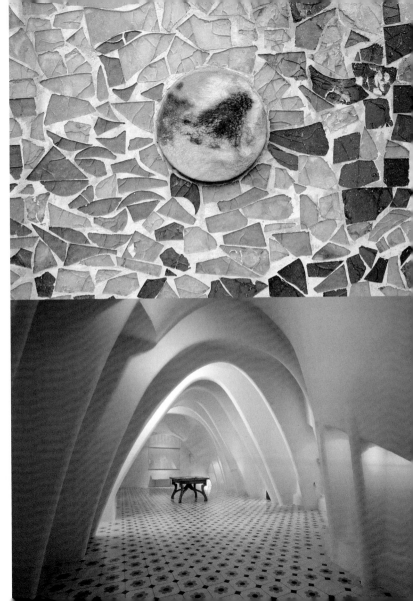

La Pedrera. At number 92 Passeig de Gràcia stands Casa Milà, also known as La Pedrera, or quarry. This residential building (today the property of the Fundació Caixa Catalunya and exhibition centre) has three façades. In reality, they all form one single surface, defined by their undulating lines, which evoke an improbable swell of stone, sprinkled with the twisted metallic railings of the balconies. The entrances to the building once again show the original brightly coloured fresco paintings. Most of the floors have recovered their initial appearance with the Modernist carpentry and the often mysterious illustrations and relief work drawn on the plaster ceilings, like signs on the sand of a desert. The variable surface of the flat roof, the biggest surprise of La Pedrera, hosts a forest of sculptural chimneys, which conceal stairways and water tanks.

La Pedrera

The tour of La Pedrera includes the visit to the Espai Gaudí exhibition space in the attic area and to a flat that reproduces the original decoration. The building is open every day from March to October between 9 a.m. and 8 p.m., and from November to February from 9 a.m. to 6.30 p.m. It has a shop-bookshop.

Passeig de Gràcia, 92
Tel. 902 40 09 73
www.fundaciocaixacata
lunya.org

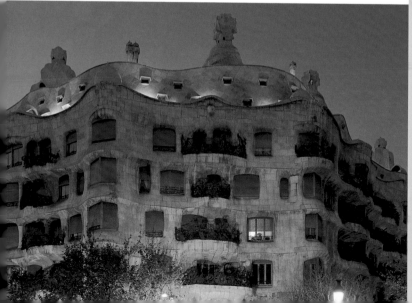

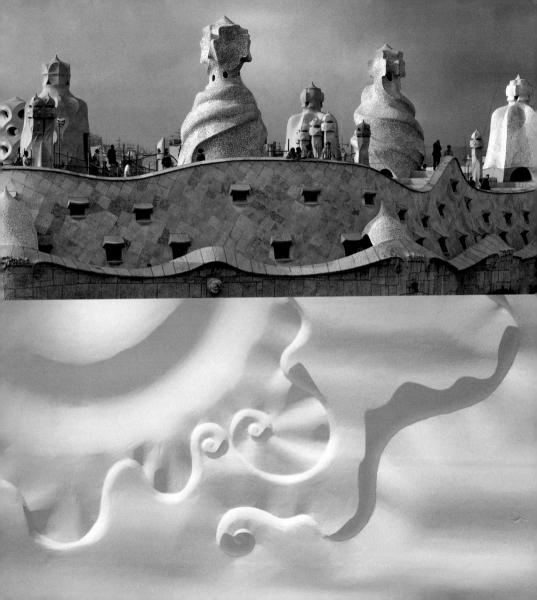

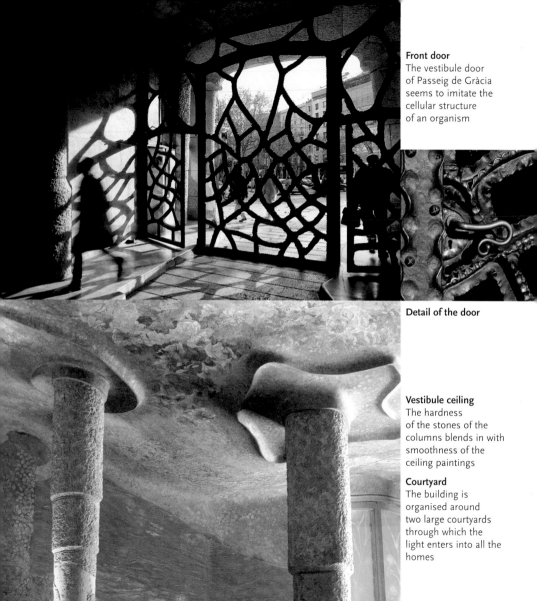

Front door
The vestibule door
of Passeig de Gràcia
seems to imitate the
cellular structure
of an organism

Detail of the door

Vestibule ceiling
The hardness
of the stones of the
columns blends in with
smoothness of the
ceiling paintings

Courtyard
The building is
organised around
two large courtyards
through which the
light enters into all the
homes

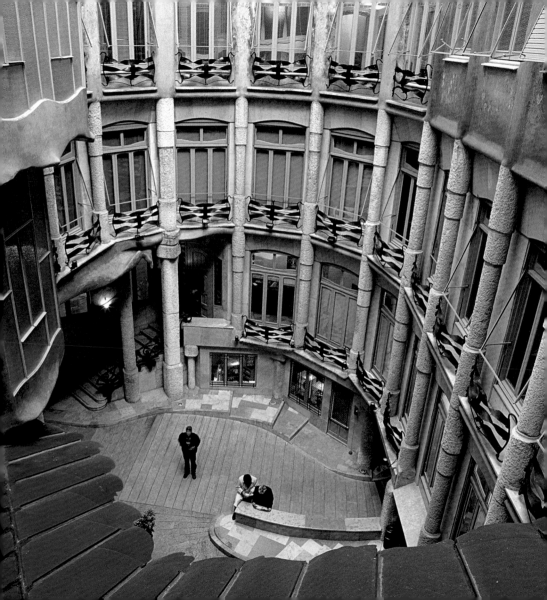

Espai Gaudí.

The attic area of La Pedrera, with its succession of 270 catenary arches in brickwork, reminds one of the inside of a giant whale. It was originally used as the laundries and drying rooms of the property, at the same time providing the building with heat insulation. Today it is the headquarters of the Espai Gaudí. This museum area, with a total area of 800 square metres, has been set up to document and explain the Gaudian work, through audiovisual projections, models and natural analogies, both in terms of its spectacular finishing touches and to its hidden and innovative structures. Completely renovated at the end of 2006, the Espai Gaudí brings together all the keys to the architecture of the genius from Reus, in a revealing and very educational account.

Different views from the attics of La Pedrera, with its brick arches, where the Espai Gaudí is based

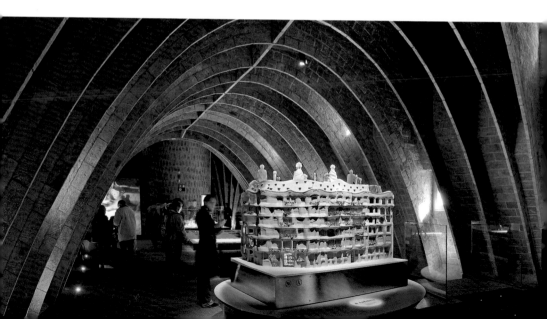

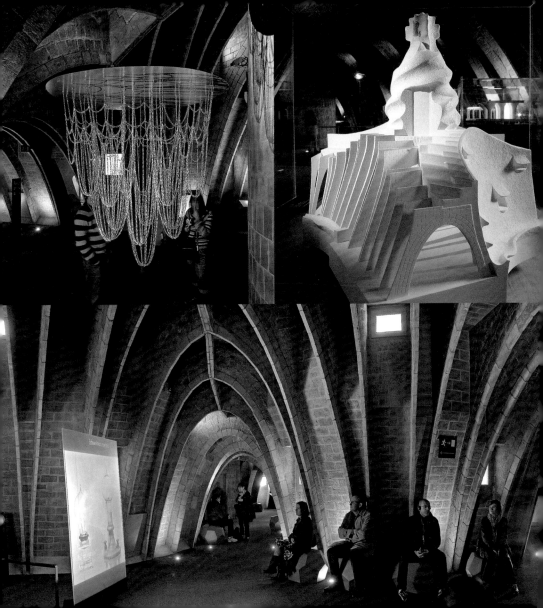

Temple of the Sagrada Família.

The Expiatory Temple of the Sagrada Família (in Plaça Sagrada Família) is remarkable for its size and ambition. This church, which occupies a whole block of the Eixample district, is a mass of profusely worked stone in cathedral-like dimensions. Built around a Latin cross ground plan with five naves, it is characterised by its stylised towers (one hundred metres high), crowned by pinnacles covered in ceramics. These towers are quite spectacular in appearance but are not, however, the biggest part planned by Gaudí: among the parts still to be built features a massive dome 170 metres high, set to become the most prominent part of the architectural piece. Work on the Sagrada Família, started in the 19th century, to which Gaudí dedicated 40 years, and which is still in progress, could be completed around 2025.

Passion Façade

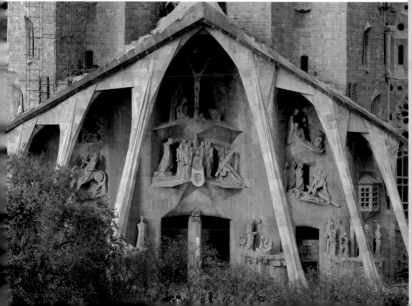

Temple of the Sagrada Família

The Sagrada Família can be visited every day, from 9 a.m. to 8 p.m. between April and September, and from 9 a.m. to 6 p.m. between October and March. The entrance ticket costs 8 euros, and allows access to the different parts of the temple (including the crypt or the schools, as well as the exhibitions...), although, due to the works, some areas of the temple cannot be seen. There are lifts in the Nativity and Passion façades which, for an additional 2 euros, take you up 65 metres to be able to get a view of the whole building.

Plaça de la Sagrada Família
Tel. 93 207 30 31
www.sagradafamilia.org

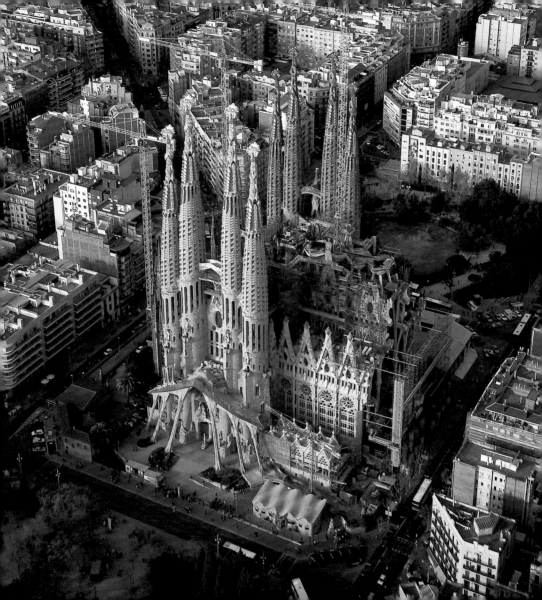

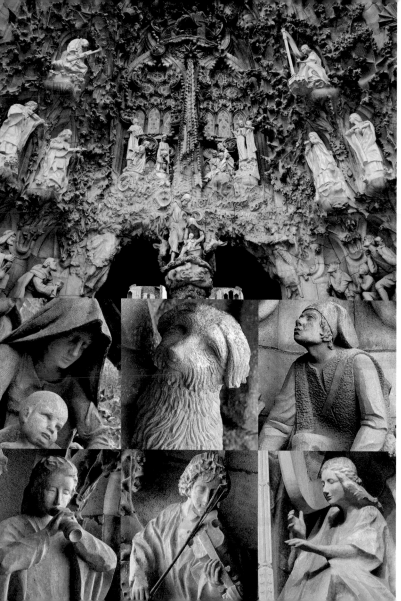

Nativity Façade
The multicoloured sculptural series of the Nativity Façade has a large number of human and animal figures

Towers
The rowers of the Sagrada Família, crowned by ceramic pinnacles, contain steep spiral staircases

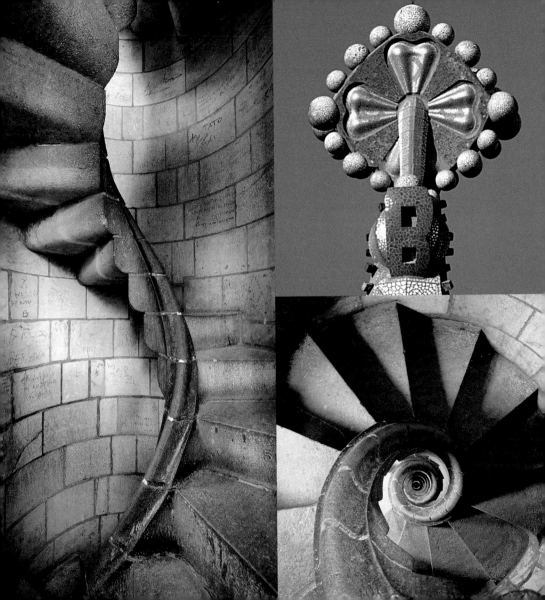

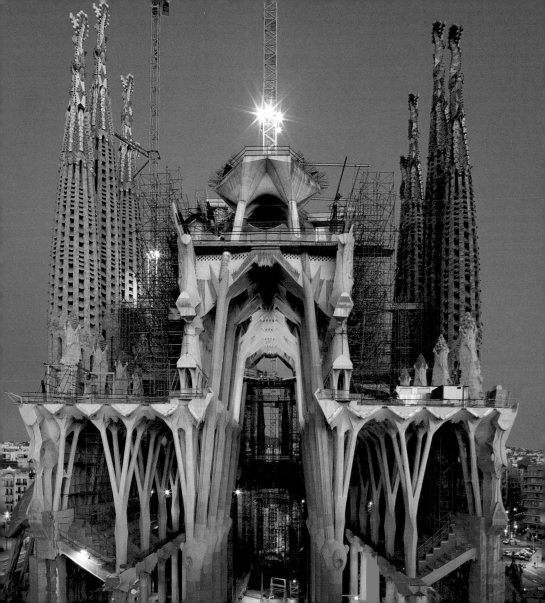

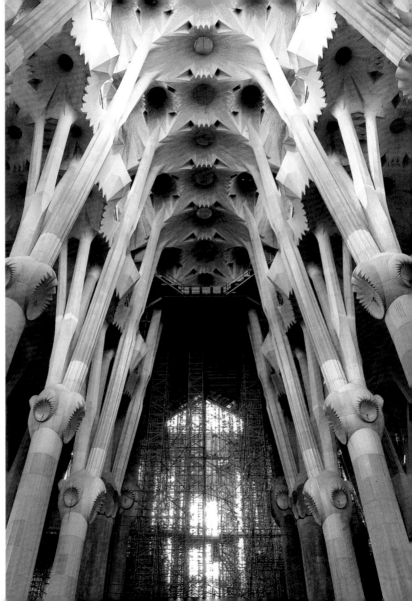

Glory Façade
Image of the works in progress on the Glory Façade, which will be the temple's main façade. In the background, the current towers

Forest of columns
The central nave of the Sagrada Família has a forest of columns, in arboreal form, ramified in their upper section

Park Güell.

Park Güell, an unfinished garden city of 20 hectares, is located beyond the Eixample district, where most of the Gaudí buildings are, but it simply must be visited. From the park entrance (in Carrer Olot s/n), you see before you a monumental entrance stairway, overlooked by a ceramic saurian. After the stairway is the Hypostyle Hall —a forest of columns— and above that, the large public square of Park Güell, offering a magnificent view over Barcelona, surrounded by its famous undulating bench, covered with the remains of tiles, plates and bottles, forming a colourful and lively collage. Other interesting parts of the park are the arcaded galleries with leaning columns, the few residences that were eventually built, and the different pathways that can be taken.

Dragon
A multicoloured saurian, covered by ceramic fragments, welcomes the visitor to Park Güell

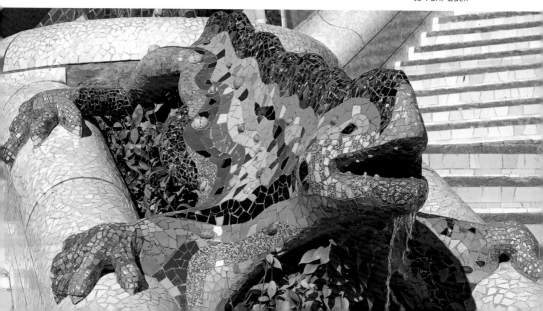

Park Güell Information Centre

Next to the entrance to Park Güell, in what was originally the porter's lodge, is the Park Güell Information Centre. The centre and visitors' reception area documents, through plans, models, photos and audiovisual projections, Gaudí's constructive systems, as well as the main characteristics of the park, and suggests the most suitable routes to be taken. It is open every day between 11 a.m. and 3 p.m.

c/ Olot, s/n
Tel. 93 319 02 22
www.museuhistoria.bcn.cat

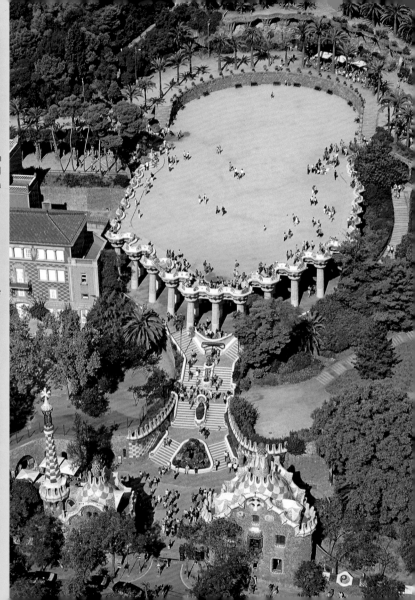

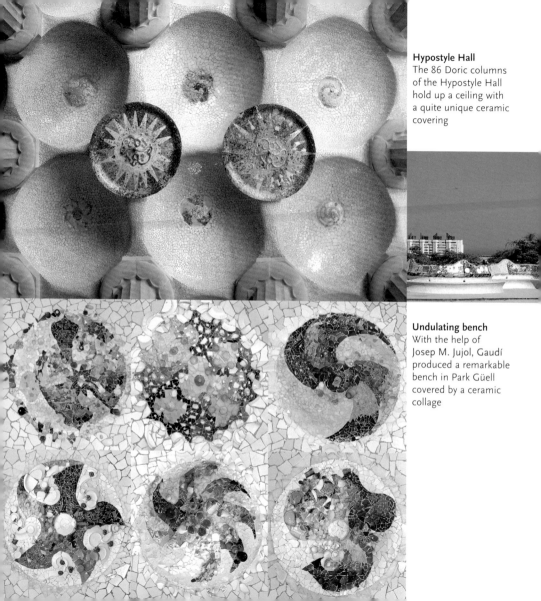

Hypostyle Hall
The 86 Doric columns of the Hypostyle Hall hold up a ceiling with a quite unique ceramic covering

Undulating bench
With the help of Josep M. Jujol, Gaudí produced a remarkable bench in Park Güell covered by a ceramic collage

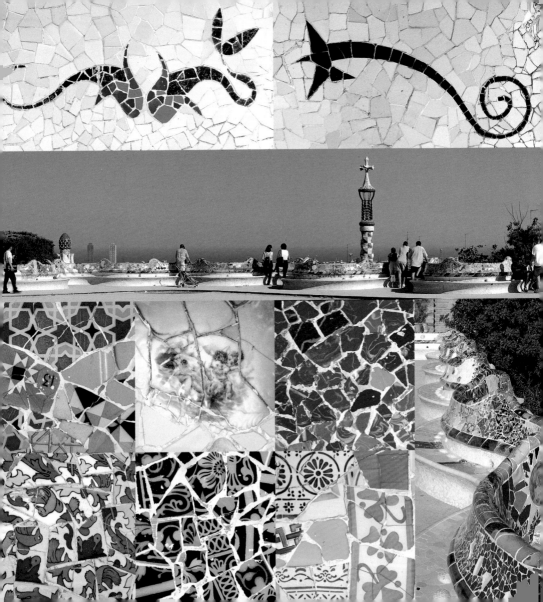

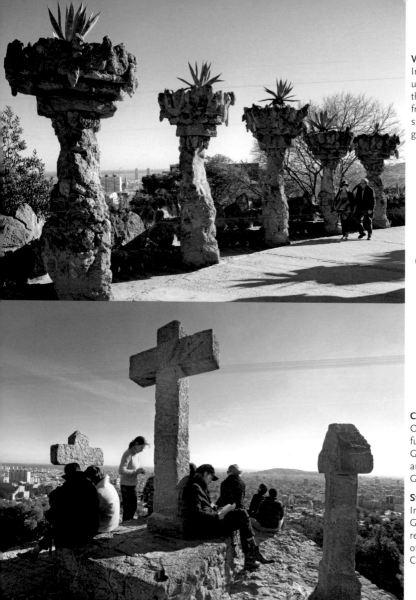

Viaduct
Image of one of the upper sections of the viaduct, made from materials taken straight from the ground

Chair
On of the items of furniture designed by Gaudí, several of which are conserved in the Gaudí House-Museum

Station of the Crosses
In the high part of Park Güell, several crosses refer to the crucifixion of Christ at Mount Calvary

Gaudí House-Museum

Gaudí lived for twenty years in one of the houses built in Park Güell. Since 1963, this building has been the Gaudí House-Museum, where many pieces of furniture designed by Gaudí are exhibited and which recreates the atmosphere in which the architect lived.

Casa-Museu Gaudí
Park Güell
Tel. 93 219 38 11
www.sagradafamilia.org

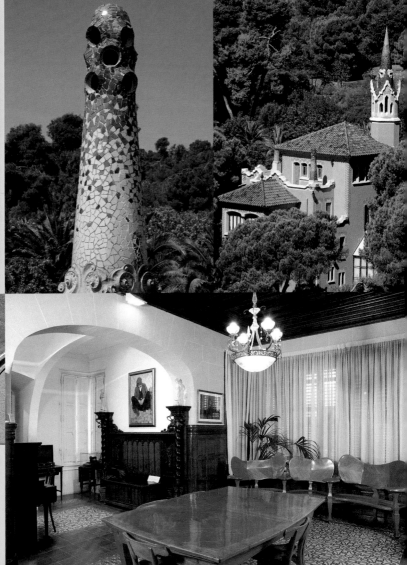

Casa Vicens.

Casa Vicens (c/ Carolines, 22) is the first major work by Gaudí in Barcelona, a detached house with a basement, ground floor and two storeys, in Mudejar style. The brickwork and ceramics are the defining aspects of this building, and it is no coincidence that it was built (1883-1888) at the behest of the ceramic manufacturer Manuel Vicens. The chequered green and white tiles, as well as the floor tiles with floral motifs, define the façade of the Casa Vicens, along with the stone coverings and very elaborate wrought-iron gate, reproducing leaves of European palms and other figures inspired by nature. The interior of Casa Vicens, not open to the public, possesses a very dense decoration, which combines ceramics, wood, glass and plaster, in settings with an Arabic or Japanese air. The garden surrounding the house has suffered diverse mutilations.

European palm grille
The ornamentation of Casa Vicens is complex, both the metallic and ceramic aspects

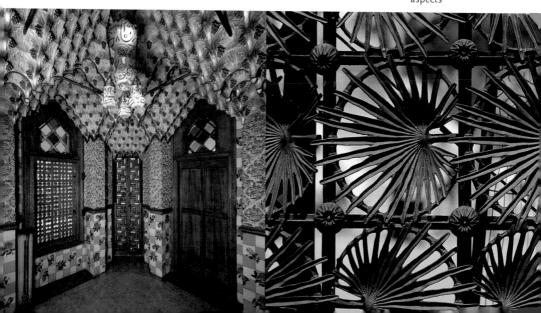

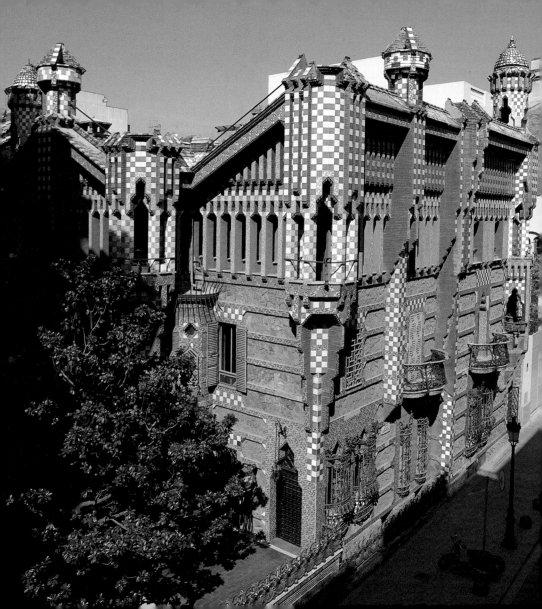

Güell Pavilions.

There is no gateway more spectacular in Barcelona than that of the Güell Pavilions (Av. de Pedralbes, 7), a piece of wrought-iron work, designed by Gaudí, that represents a fierce dragon, originally strengthened by a bright polychrome effect and a mechanism that gave it movement. This dragon stands guard over the pavilions of the porter's lodge and the stables of the large estate owned by Eusebi Güell, the architect's patron, where today the Avinguda Diagonal ends. This is where the first joint venture between the two of them was built. The pavilions, contemporary to the Casa Vicens, are in neo-Mudejar style. The stables, with their parabolic arches, today house the Real Cátedra Gaudí, a study centre. Both elements formed part of an estate, later razed to make way for the Royal Palace of Barcelona, the rehabilitation of which involved Gaudí. The gardens surrounding the Güell Pavilions recreate the myth of the Garden of the Hesperides.

Orange tree
An orange tree crowns the column of the entrance to the Güell Pavilions, recalling the Garden of the Hesperides

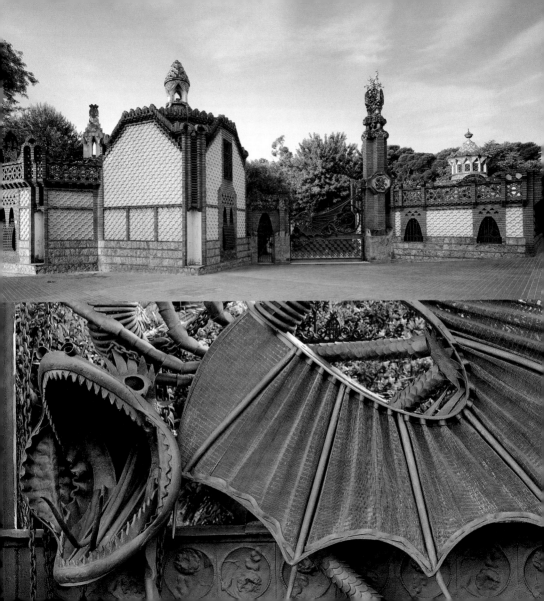

Palau Güell. At Carrer Nou de la Rambla, 3-5 stands the Palau Güell, the opulent family residence that Gaudí built for Eusebi Güell between 1886 and 1888. The richness of this building is evident even from the façade, defined by two doorways for carriages, with elaborate iron railings, among which is placed a Catalan coat of arms, similarly worked in great detail. It is inside, however, where the Palau Güell shows off all the richness that its owner demanded of Gaudí. Starting with the underground stables, where thick brickwork columns give it a monumental air, everything in this palace is majestic. Particularly stunning is the symmetrical central hall covered with a perforated parabolic dome that provides natural light and gives the whole a celestial quality. The flat rooftop of the building houses twenty chimneys decorated with ceramics.

Chimneys
The plant-inspired cowls, richly polychromed, define these chimneys

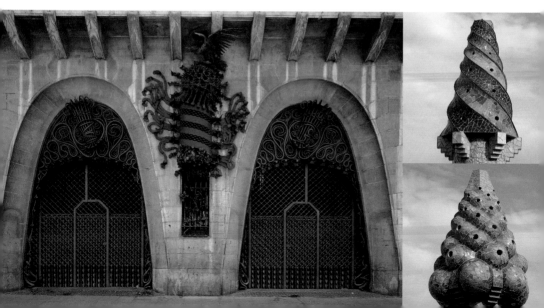

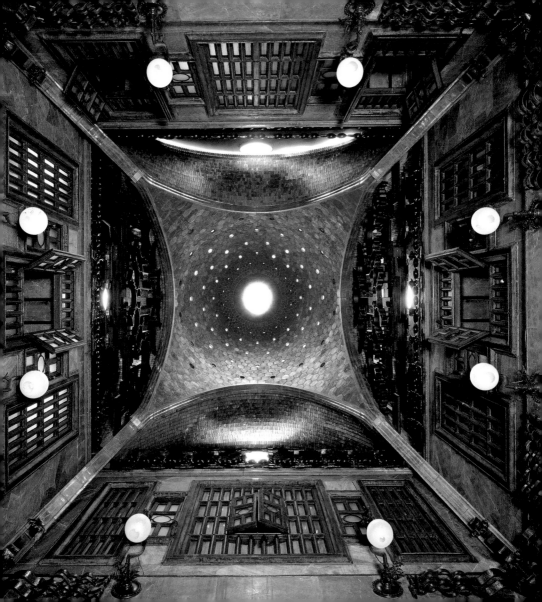

Casa Calvet.

In Casa Calvet (c/ Casp, 48), Gaudí faced the challenge of building the typical property of Barcelona's Eixample district: a building between party walls, with basement, ground floor used for a textile business, first floor for the owners and three more floors for rented homes. Although the grey Montjuïc stone of the façade is common in this public area, despite its relative discretion of Baroque aftertaste —both in the sinuous cornice and the balconies, pre-dating those of the later Casa Batlló— Casa Calvet contains excellent examples of Gaudí's inventiveness. Among them feature the knobs, knockers and peep-holes, sometimes inspired by organic forms and results approaching the very best craftsmanship in precious metals. Gaudí also designed the furnishing for the ground floor business, today fitted out as a restaurant, and the first floor; some pieces are still present on the property, while others are on show in museums.

Peephole
The organic forms and treatment of the metals make this peephole seem like a piece of silversmith work

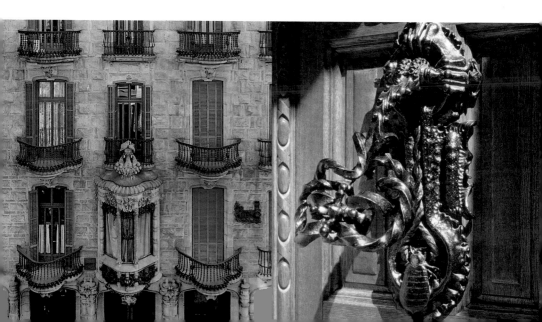

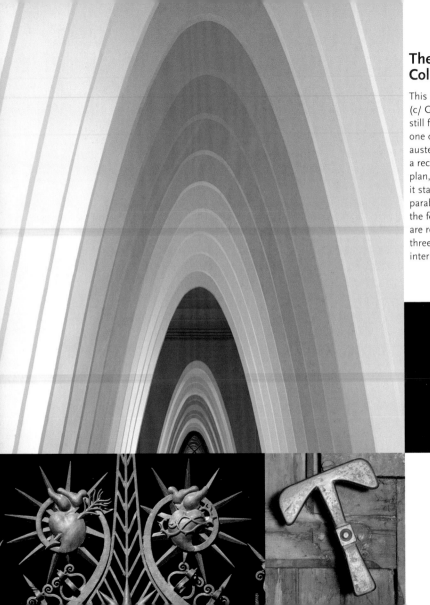

Theresan College

This religious school (c/ Ganduxer, 85), still functioning, is one of Gaudí's most austere works. With a rectangular ground plan, built in brick, it stands out for its parabolic windows, the forms of which are repeated in the three light-filled interior corridors.

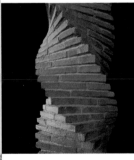

Bellesguard Tower

An architecture with stylised, Gothic echoes defines this residence in the high part of Barcelona (c/ Bellesguard, 16), built in the early-20th century over the remains of a palace owned by King Martí the Humane, and with a steeple tower crowned with a six-armed cross.

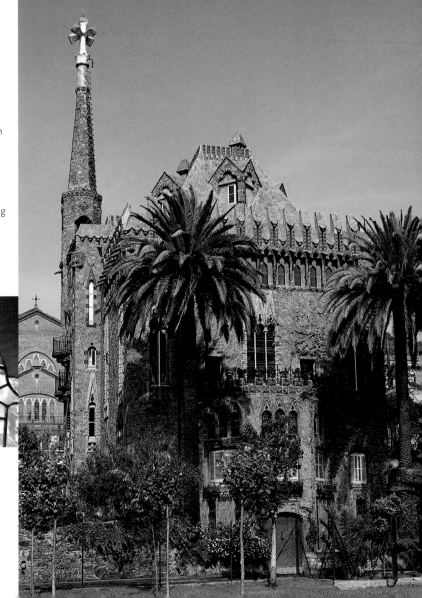

Crypt of the Colònia Güell.

In the Güell Industrial village of Santa Coloma de Cervelló, some twenty kilometres southwest of a Barcelona, is one of Gaudí's most expressive works: the crypt of the village church, the only part of it that was ever built. This building, where the combination of the materials, the inclination of the columns and a fanciful morphology suggest a craftsman-like air, irregular and even unstable, is based on a rigorous and innovative structural project by Gaudí. The architect studied the loads that the columns and arches had to withstand in great detail, developing models made with strings and weights, in a process that took a decade to solve and in which photography played a very important role. The result is a singular piece of work, in which there is a harmony between the brick, basalt stone, ceramic, iron, stained-glass windows and the Gaudian furnishings.

Columns
Formal diversity and dynamism define the columns that support the crypt of Colònia Güell

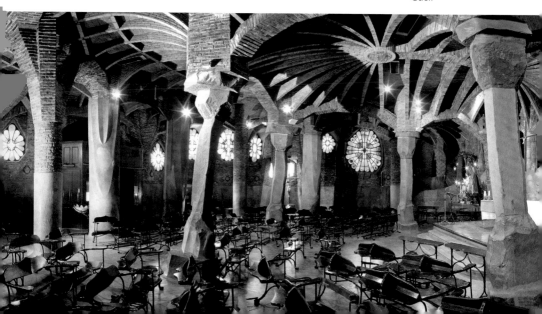

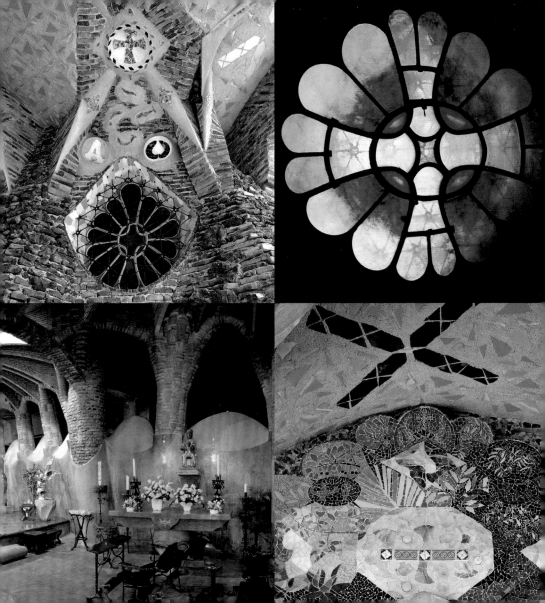

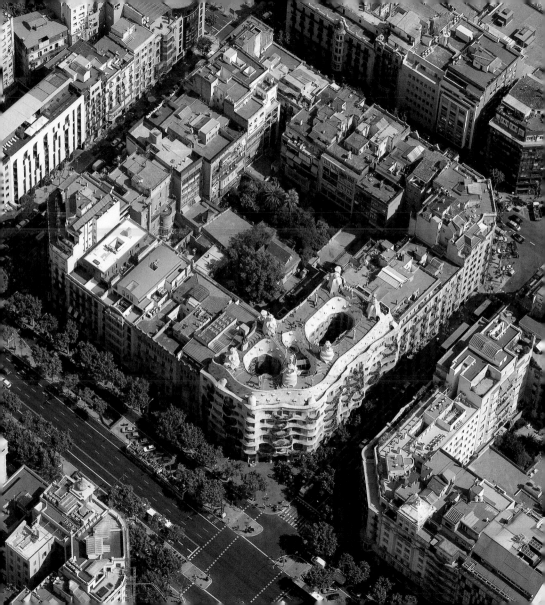

The Eixample and Modernism

The Eixample, a residential and services district, is the central part of modern Barcelona. Until the mid-19th century, Barcelona was a city constricted by its walls. In 1856, however, the engineer Ildefons Cerdà presented his project for the enlargement of the city, a visionary plan that was going to adapt the city to its needs of the time and also to those of the future. Broadly speaking, Eixample could be defined as a project for the growth of Barcelona and to link it with the small neighbouring towns, in the search for acceptable conditions of circulation, healthiness and, specifically, the density of occupation which totally revolutionised the standards of the time, and which today, in the 21st century, are still operative.

The Eixample is the best suit of modern Barcelona and as such constitutes an exquisite example of what in Catalan is called *seny* —the balanced and sensible side of the local character. Such style was suitably complemented by Modernism, which was responsible for illuminating with vibrant fabrics and colours —in this case stone, ceramics, iron and glass— the new city's clothing. Modernism would be, in this sense, a result of the Catalan *rauxa* —the crazy and unpredictable nature of the local character— which acts as a counterbalance to the just mentioned *seny*. It was also Barcelona's contribution to a period of special splendour in European architecture, the turn of the 19th and 20th centuries, which developed along similar lines but with distinct nuances in cities such as Paris, London, Vienna or Munich, among others.

Block
The block containing La Pedrera, in Passeig de Gràcia, is one of the typical islands of homes in the Eixample district

Paving tiles
The pavements of Eixample are covered with square paving tiles with geometric and floral motifs

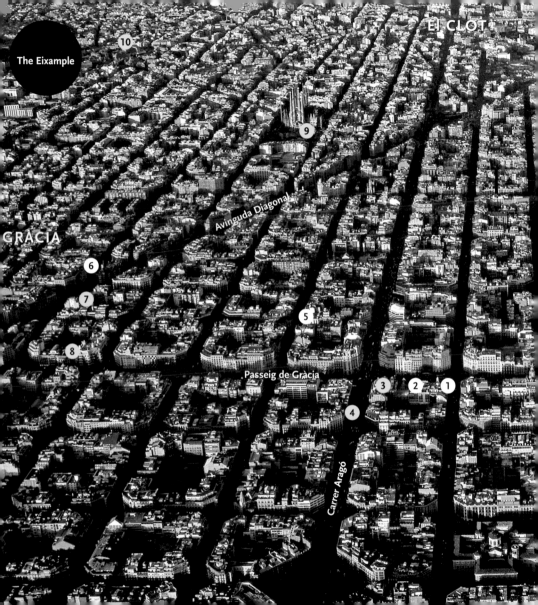

The Eixample

EL CLOT

GRÀCIA

10

9

Avinguda Diagonal

6

7

8

5

Passeig de Gràcia

3 2 1

4

Carrer Aragó

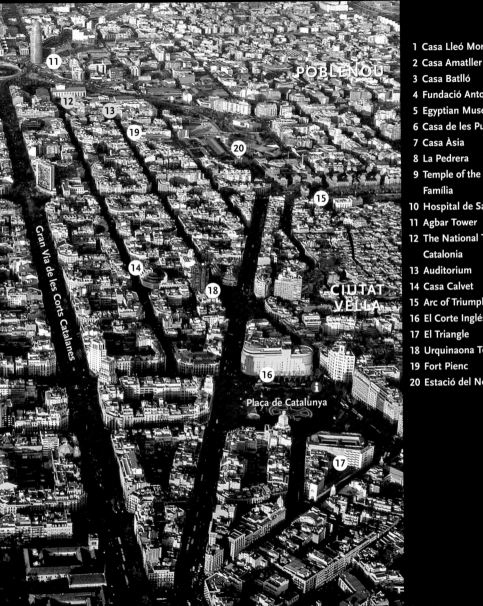

POBLENOU

CIUTAT VELLA

Gran Via de les Corts Catalanes

Plaça de Catalunya

1 Casa Lleó Morera
2 Casa Amatller
3 Casa Batlló
4 Fundació Antoni Tàpies
5 Egyptian Museum
6 Casa de les Punxes
7 Casa Àsia
8 La Pedrera
9 Temple of the Sagrada Família
10 Hospital de Sant Pau
11 Agbar Tower
12 The National Theatre of Catalonia
13 Auditorium
14 Casa Calvet
15 Arc of Triumph
16 El Corte Inglés
17 El Triangle
18 Urquinaona Tower
19 Fort Pienc
20 Estació del Nord

The Eixample and Modernism.
On the ground, the Eixample is an orthogonal reticle, only altered by its main streets: the stately Passeig de Gràcia (where at the beginning of the 20th century, the people of Barcelona strolled up and down to see and be seen), Carrer Aragó and Gran Vía de les Corts Catalanes (which crosses it lengthwise), Avinguda Diagonal (which crosses it diagonally) and the odd large public square, such as Plaça de Catalunya.

The elevation of Eixample, however, is something quite distinct. When the majority of its buildings were erected, Catalonia was experiencing a healthy economic period that had its roots in the early 19th century, the period in which Barcelona was developing as the country's economic driving force, fuelled by the industrial revolution and further boosted by the feverish activity of the first two decades of the last century, when Catalan factories became the main suppliers to the European nations at war.

This economic boom, along with cultural movements that emphasised

Plaça de Catalunya
With its esplanade, fountains and statues, it links Eixample with the old part of the city

Passeig de Gràcia
Long thoroughfare, which links Plaça de Catalunya with the old town of Gràcia

"Motherhood", by Vicenç Navarro

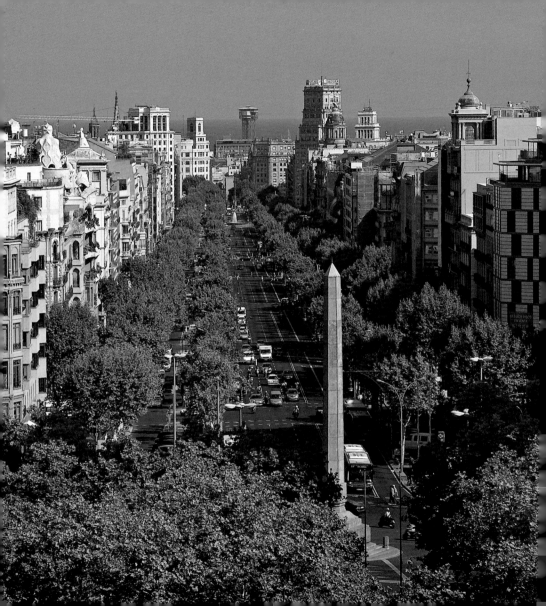

the national identity, such as the *Renaixença* and the re-emergence of the applied arts, coincided with the dawning of Modernism and substantiated it.

Barcelona is the city of Gaudí, the brilliant and unclassifiable figure who coincided in time with Modernism. But Barcelona is also the city of this architectural movement —Modernism— that should be considered as the free coexistence of dozens of architects, hundreds of promoters and thousands of craftsmen. This confluence of genius, willingness and talent perhaps finds its most exuberant expression in the Palau de la Música Catalana, work of Domènech i Montaner, one of the most beautiful and startling concert halls in the world, which we have already mentioned in an earlier section. It is in the Eixample district, however, where the greatest concentration of Modernist architecture is to be found and, above all, the expression of the many craft skills that gave the buildings form and brilliance. Professionals in the fields of sculpture, mosaic, wood, glass, painting or sgraffito joined forces to transform Eixample into a series

Lampposts
Those on Passeig de Gràcia, designed by Falqués, are metallic, Modernist and with a ceramic bench at their base

Casa Amatller
Image of the interior courtyard and main stairway of Casa Amatller, in Passeig de Gràcia

of overwhelming fantasy-like constructions which were situated, para-doxically, over an extremely rational urban layout. For this reason, strolls around the Eixample, even after visiting the major works, are pleasant and surprising as you continually discover the constructive splendour of the period, whether by coming across a large building or a small shop. Balconies, capitals, railings, galleries, columns, cupolas, mosaics, sgraffitos, cornices, hallways, shop windows, stairways or lifts often reveal tiny treasures for those who know how to seek them out. These treasures may be insuperable in some interiors, veritable masterpieces of the applied arts, and which also stand out in the street, in a large number of façades and doorways. It is precisely this creative richness that makes Modernist Barcelona a singular point of reference in the setting of European cities that experienced a specific period of constructive splendour between the 19th and 20th centuries.

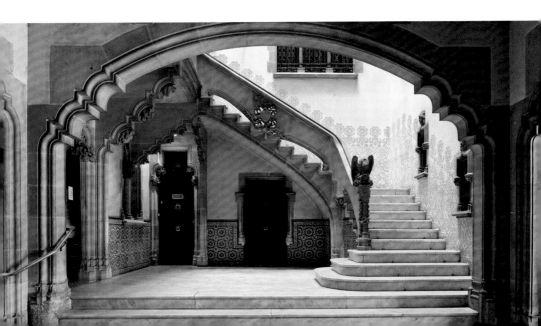

Blooming craftsmanship
Modernism represented the blooming of craftsmen in ceramics, glasswork, stone, iron and plaster

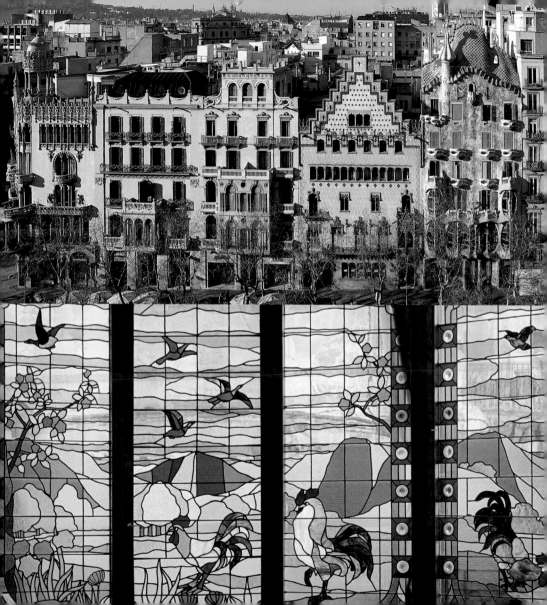

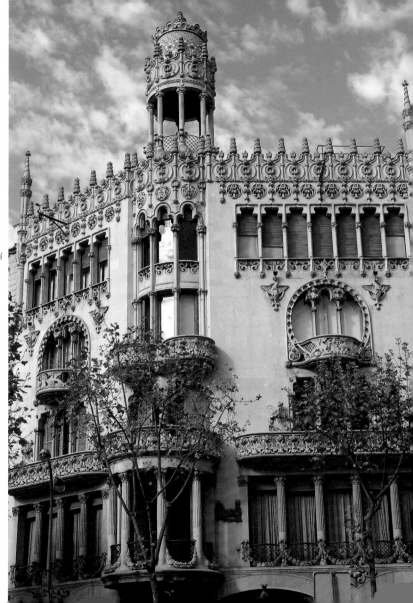

Apple of Discord
What is known as the Apple of Discord (apple, manzana in Spanish, also means block of buildings) brings together constructions by the great Catalan architects of the early 20th century, such as those of Casa Lleó Morera, by Domènech i Montaner; Casa Amatller, by Puig i Cadafalch; and Casa Batlló, by Antoni Gaudí

Casa Lleó Morera
On the right, façade of Casa Lleó Morera. On the previous page, detail of the windows on the main floor of this building, situated on the rear façade

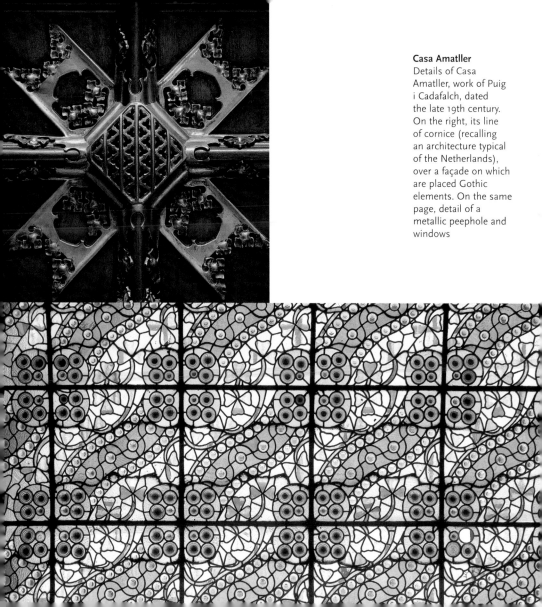

Casa Amatller
Details of Casa Amatller, work of Puig i Cadafalch, dated the late 19th century. On the right, its line of cornice (recalling an architecture typical of the Netherlands), over a façade on which are placed Gothic elements. On the same page, detail of a metallic peephole and windows

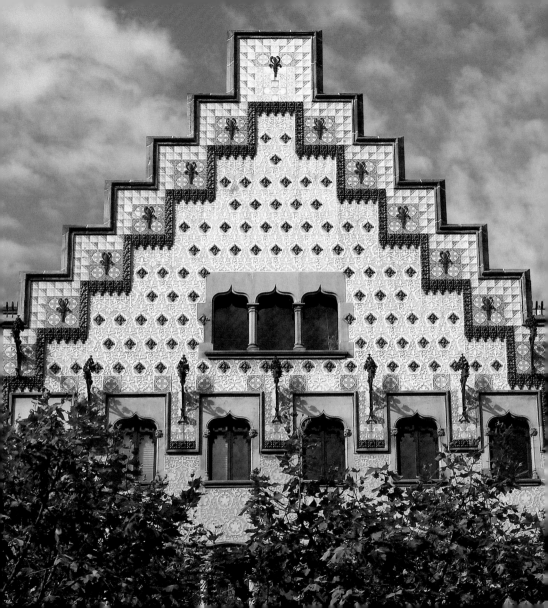

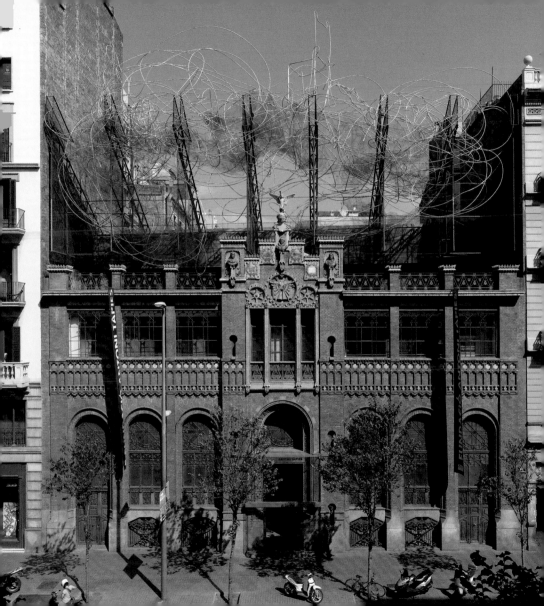

Fundació Antoni Tàpies

In 1990 the painter Antoni Tàpies opened his foundation in the old Montaner i Simón publishing house, a brick and iron building completed by the architect Domènech i Montaner in 1885. This centre, crowned with a sculpture by its promoter —*Núvol i cadira* (Cloud and chair)—, possesses one of the best collections by Tàpies (paintings, sculptures, drawings, etchings and books), whose exhibition alternates with temporary shows by other contemporary artists. The artist's library is also housed here.

c/ Aragó, 255
Tel. 93 487 03 15
www.fundaciotapies.org

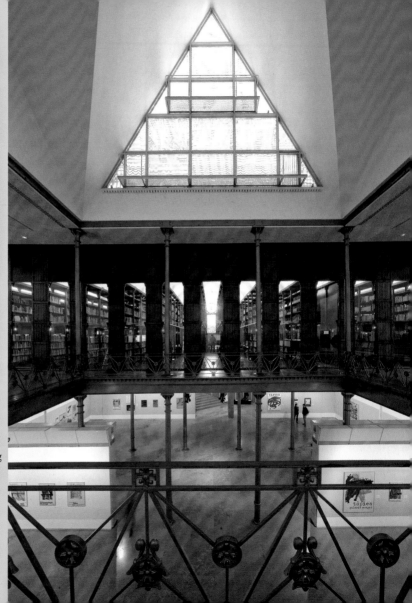

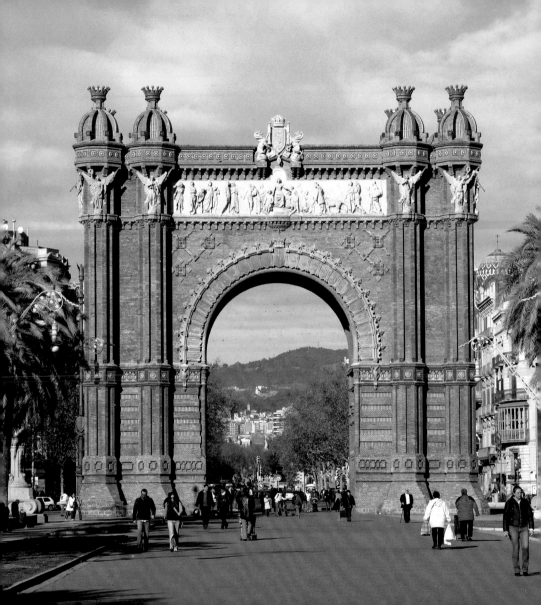

Arc of Triumph
Open brickwork arch that was the entrance to the Universal Exhibition of 1888

Casa de les Punxes
On an irregular triangular block in Eixample, facing the Diagonal, Puig i Cadafalch built Casa de les Punxes (house of points), a construction with a neo-Gothic air, which stands out for the pointed crowning of its towers and cornices. This work, mainly in brickwork, also possesses interesting items in stone

Stone cyclist
Relief work on the façade of Casa Macaya

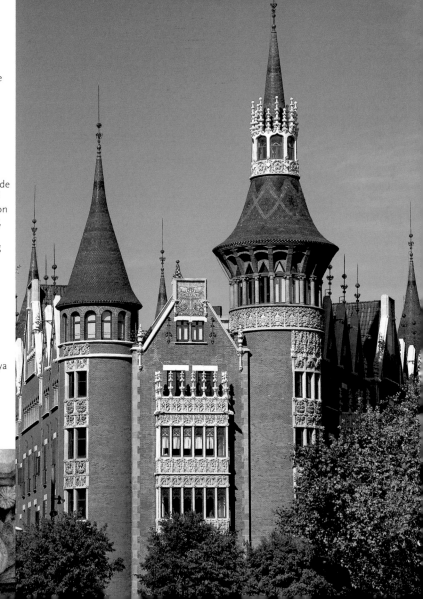

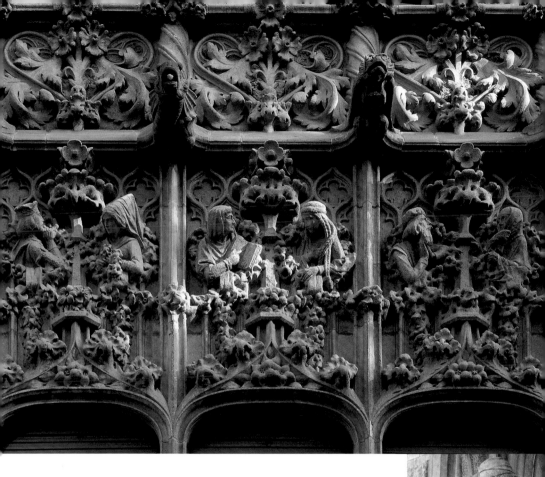

Casa Àsia

Since 2003 the Casa Àsia has been established in Barcelona, a centre providing cultural and reference information about Asia and the Pacific region. Located in the central Palau Baró de Quadras, the work of the Modernist architect Puig i Cadafalch, Casa Àsia houses exhibitions, film showings, conferences and courses that offer a meeting space between Spanish society and the Oriental world. It has a large media library and space to undertake research projects.

Av. Diagonal, 373
Tel. 93 368 08 36
www.casaasia.es

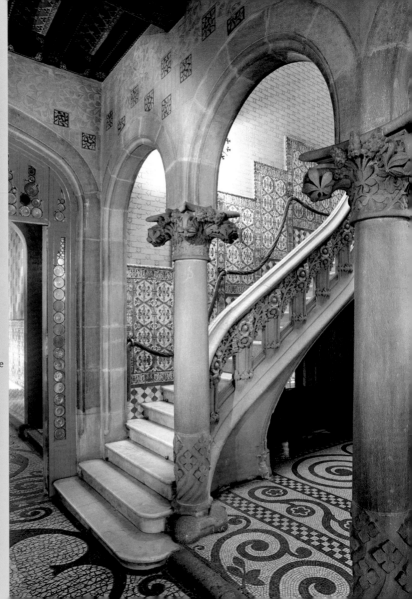

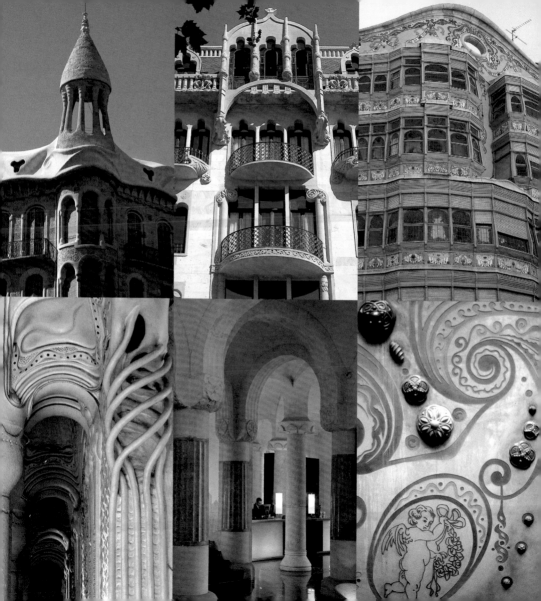

Eixample is a continuous explosion of Modernism. The attentive passer-by will come across constant examples of aesthetic joy on façades, galleries and balconies, in sgraffito, mosaics and carpentry, which reflect a period of great craftsmen's skills and unique ornamental taste.

On the next page, details of façades and interiors of Casa Sayrachs (Av. Diagonal, 423), Casa Fuster (Passeig de Gràcia, 132) and Casa Comalat (Av. Diagonal, 422 and c/ Còrsega, 316). On this page, details of Casa Llopis (c/ València, 339) and Casa Planells (Av. Diagonal, 332)

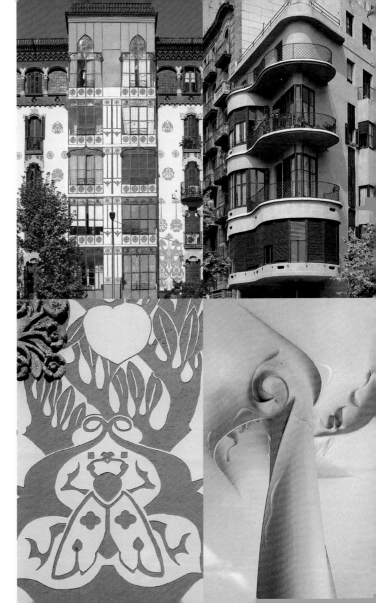

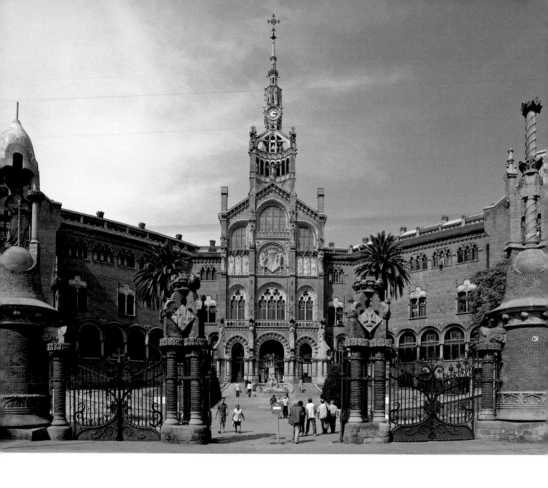

Hospital de Sant Pau

The Hospital de la Santa Creu i de Sant Pau, built by Domènech i Montaner between 1913 and 1930, is one of the major works of Modernism. It occupies the equivalent of nine blocks of Eixample and in its original design had a total of 46 independent halls, ordered according to a new form of hospital and urban organisation. The administration hall, the church and the convalescence home are amongst its most outstanding elements.

c/ Sant Antoni Maria Claret, 167-171
Tel. 902 07 66 21
www.santpau.cat

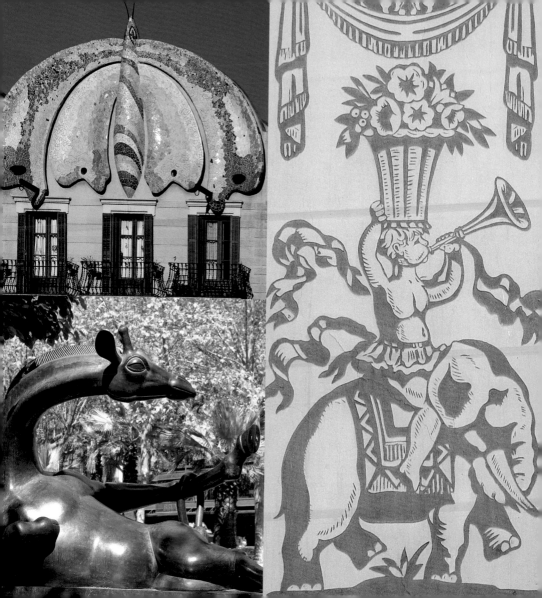

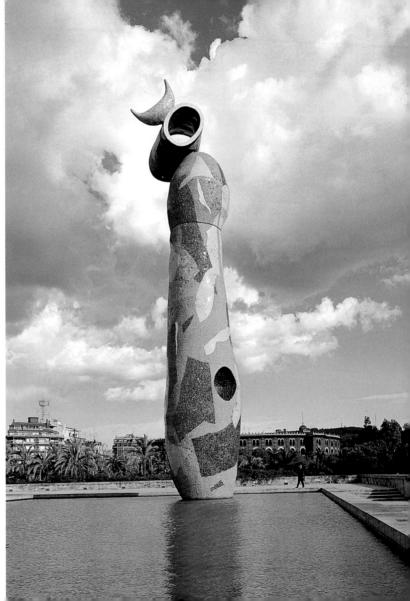

Butterfly
Animal motifs, such as this ceramic butterfly that crowns Casa Fajol (Llançà, 20), abound in Barcelona

Giraffe
One of the sculptures with an animal motif installed in Rambla de Catalunya. It is the work of Josep Granyer

Elephant
Detail of sgraffito by the Ramon Llull school group (Av. Diagonal, 269)

Escorxador Park
On this page, the stylised sculpture "Woman and bird", built by Joan Miró in Escorxador Park

The streets of Eixample have shops from different periods, from the traditional grocers to cutting-edge design shops

Egyptian Museum
Funerary mask exhibited in the Egyptian Museum (c/ València, 284)

The Agbar Tower
has become a new
architectural icon for
Barcelona, now in
the 21st century: the
silhouette is visible
from many streets of
a city that combines
old and renovated
buildings

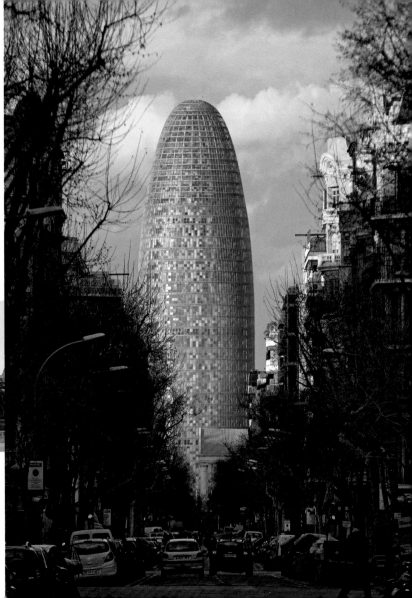

Palau Robert
Headquarters of the
Catalonia Information
Centre. It has
exhibition rooms and
a tourist information
office (Passeig de
Gràcia, 107)

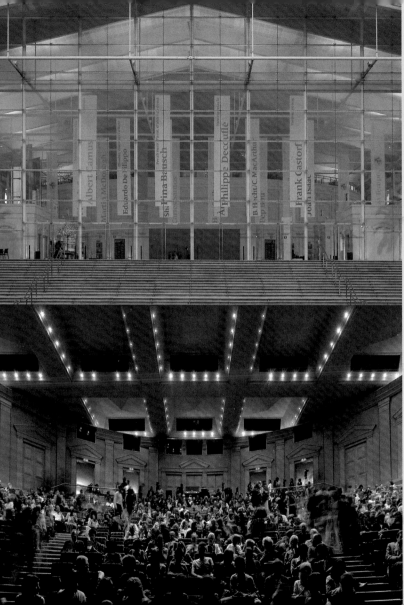

Teatre Nacional de Catalunya

The National Theatre of Catalonia (TNC) was opened in November 1996 in a building of clearly classical inspiration, designed by Ricardo Bofill. It measures 25,000 square metres and has three stages with a capacity, respectively, of 900, 400 and 300 spectators. It puts on around 20 productions each season, from internationally known or local classics, through to new authors, and even dance shows and shows aimed specifically at children.

Plaça de les Arts, 1
Tel. 93 306 57 00
www.tnc.cat

L'Auditori

The Barcelona Auditorium opened in 1999. Its headquarters is the cubic building designed by Rafael Moneo, with a sober exterior and some very high quality wooden interior coverings. The main hall has a capacity for 2,200 people, and the other two halls 600 and 400. Its 42,000 square metres also house the Higher School of Music of Catalonia and the Music Museum. It is the regular stage of the Barcelona and Catalan National Symphonic Orchestra. It is next to the TNC.

c/ Lepant, 150
Tel. 93 247 93 00
www.auditori.cat

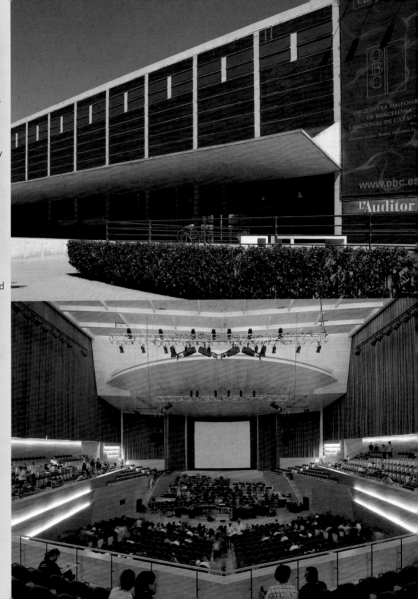

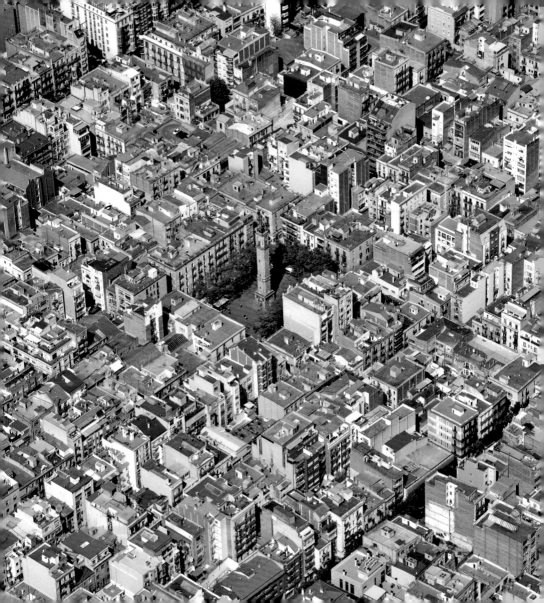

The old towns

Barcelona encompasses several cities within its area of influence. Since Cerdà planned the Eixample, the central urban layout of Barcelona has been defined by its uniform reticle of streets and blocks, only interrupted by some big avenues such as Diagonal or Passeig de Gràcia. The Eixample, however, as well as giving character to Barcelona, is also the urban fabric that reaches and connects a whole series of previously existing towns, situated just a few kilometres from the old walled Barcelona. All of them form part of Barcelona today, but all of them still maintain their characteristic traits. The former town of Gràcia, with its narrow streets, cosy squares and bustling population, conserves a personality and some of its own customs in the heart of Barcelona. In the high part, Sarrià, Sant Gervasi and Horta show distinct ways of adapting from their residential past charm to the modern greater Barcelona, in the same way as the old towns of Sants, Sant Martí or Sant Andreu have done, situated on either side of Eixample. Special mention should be made of Poble Nou, next to the Mediterranean, where the Olympic transformation of 1992 and, entering into the 21st century, the construction of the Forum area and the new technological district of 22@ have replaced the old industrial fabric with an impressive "downtown" Barcelona.

Plaça Rius i Taulet
The dense urban layout of the former town of Gràcia opens up to one of its lightest parts in Plaça Rius i Taulet

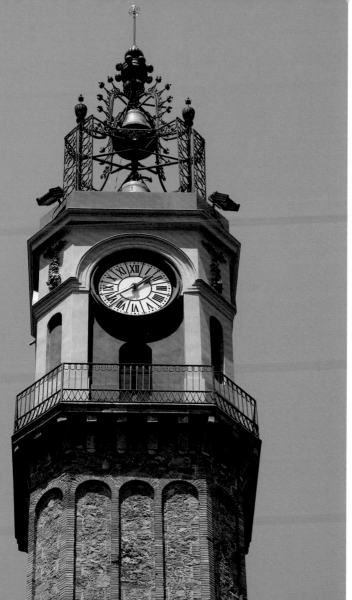

The "bell tower of Gràcia"
At 33 metres height, the solid clock tower, known popularly as the "bell tower of Gràcia" overlooks Plaça Rius i Taulet, in the heart of Gràcia

Jaume Fuster Library
The cultural facilities in Gràcia have been enhanced with the Jaume Fuster Library, in Lesseps

Terraces
The squares of Gràcia, fitted out with bar terraces, are a meeting point for the district's residents and visitors alike

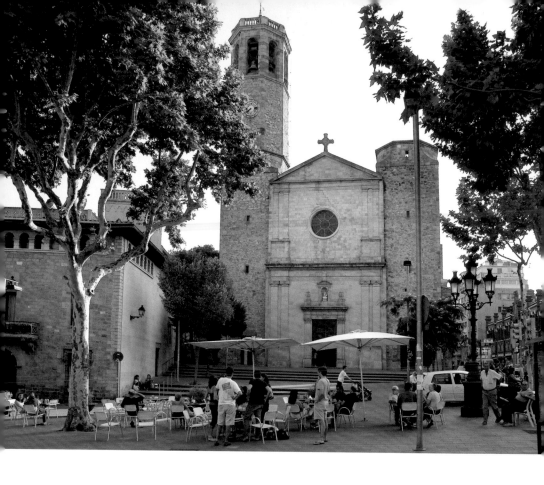

Plaça de Sarrià
The temple of Sant Vicenç, in neo-classical style and with an octagonal bell tower, overlooks Plaça de Sarrià

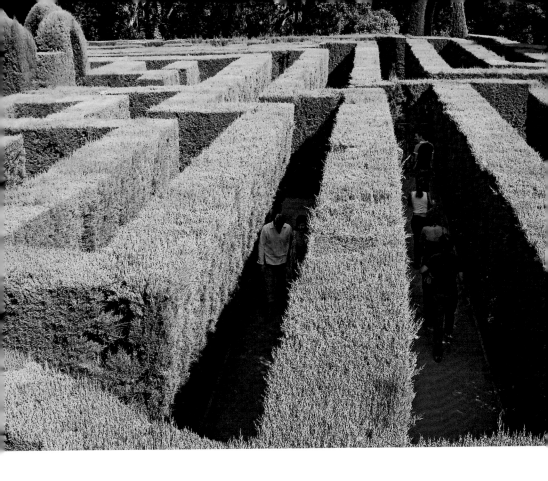

The Horta Maze
On the old estate
of the Marquises of
Llupià is the Horta
Maze, made from
cypress trees

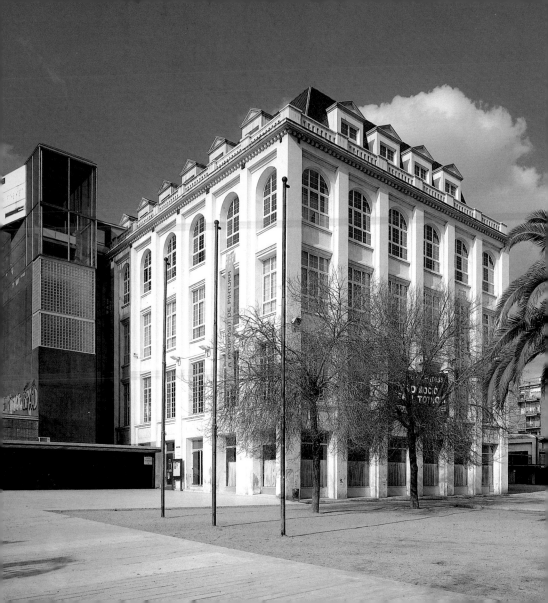

Poblenou

The continuous transformation of Barcelona pursues the renovation of its installations without losing the character of each of its corners. An example of this policy is Can Felipa, an old factory turned into a swimming pool, sports centre and homes

22@

Image of the area of Poblenou known as 22@, in which Barcelona is constructing its technological district

Parc de l'Espanya Industrial

View of this park that occupies the land of an old factory in Sants

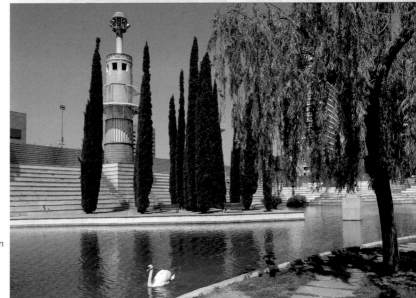

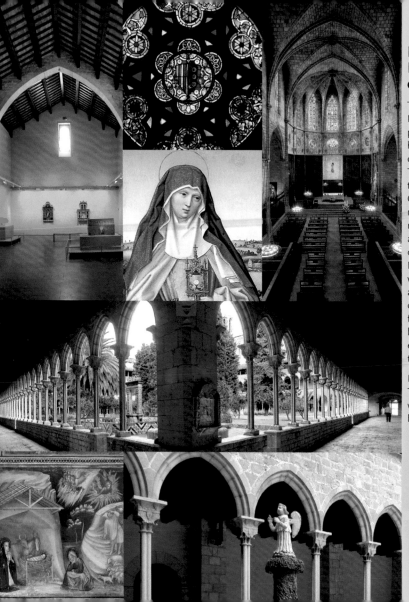

Museum-Monastery of Pedralbes

The monastery of Pedralbes, in the high part of Barcelona, has housed a religious community since 1327. The centre is one of the best examples of Catalan Gothic, and is made up of a church, monastic residence and a beautiful cloister of three floors. The Museum-Monastery was opened in 1983, and houses collections of painting, ceramics, furniture, silverwork, liturgical objects, etc. The entrance ticket costs 4 euros.

Baixada del Monestir, 9
Tel. 93 203 92 82
www.museuhistoria.
bcn.cat

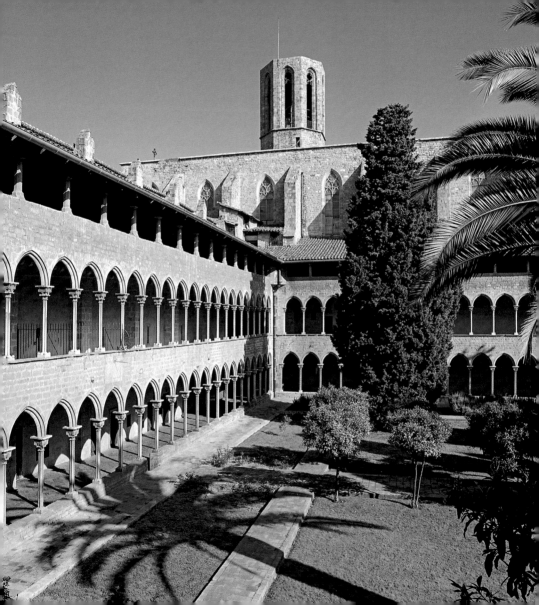

Museum of F.C. Barcelona

The best way of discovering the world of *Barça* is to go to one of their games. However, since 1984, Barcelona Football Club has provided another option: a visit to their museum, in the installations of the Camp Nou stadium. Every year over one million people visit the museum, measuring 3,500 square metres, where on show is a historic collection of trophies, images and sporting information about the club, along with other archives and temporary shows.

Av. Maillol, s/n
Tel. 93 496 36 00
www.fcbarcelona.com

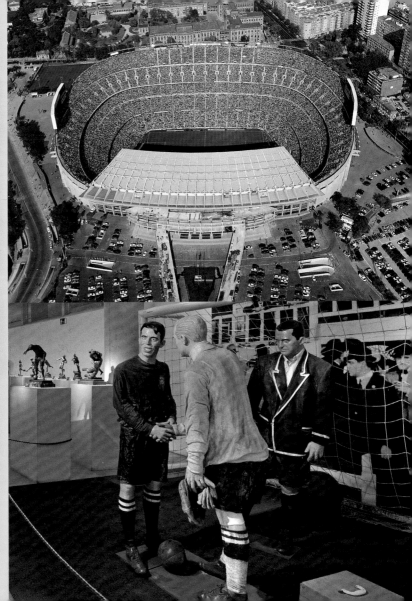

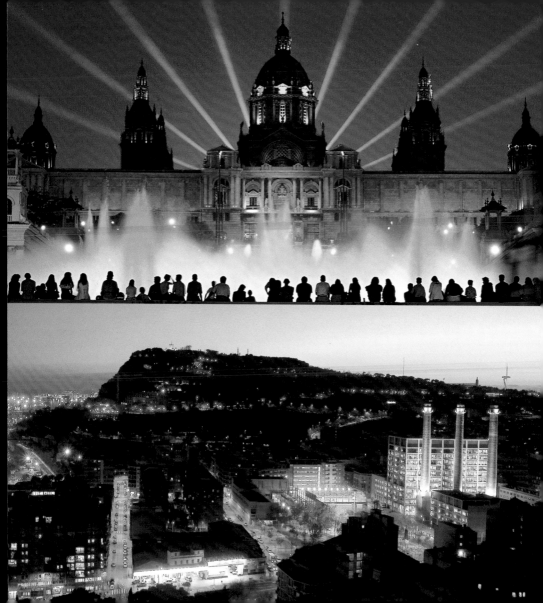

Montjuïc

The mountain of Montjuïc, which closes off Barcelona at is south end, has been the setting for grand challenges and mass celebrations. Some of them have been quite extraordinary, capable of opening up new horizons for the city, such as the International Exhibition of 1929 or the Olympic Games of 1992. Other more regular, bustling and uninhibited ones are also held, such as the patron saint festivals of the Mercè. Montjuïc shelters the sea port and forms a natural defensive position for the city. This was its main function until, with the holding of the International Exhibition of 1929, the mountain was subjected to its initial development, which left conference halls of an academic architecture behind (with exceptions such as the visionary building by Mies van der Rohe), the Poble Espanyol (a summary of Spanish popular architecture), as well as winding avenues and romantic gardens. The second big development stage was undertaken for the 1992 Olympic Games. Its most visible aspect is the Olympic Ring, a level area in classical style and symmetry, punctuated by diverse sports installations, such as Palau Sant Jordi (work of Arata Isozaki), the roof of which reminds one vaguely of a tortoiseshell, the Olympic pools (Gallego/Fernández), a sports university (Bofill) and the old Olympic Stadium (totally renovated by Correa/Milà/Gregotti). It was in this stadium on the 25th of July 1992, shortly after sundown, that a flaming arrow flew through the sky. Hundreds of millions of television viewers held their breath, until the flying torch lit the flame that opened the Olympic Games and at the same time, lit up a new Barcelona, affectionately rebuilt for the occasion.

Palau Nacional
The home of the National Museum of Art of Catalonia (MNAC). In the foreground, the fountains of Montjuïc

Montjuïc
Early evening view of the mountain area of Montjuïc, a natural defence for the city of Barcelona

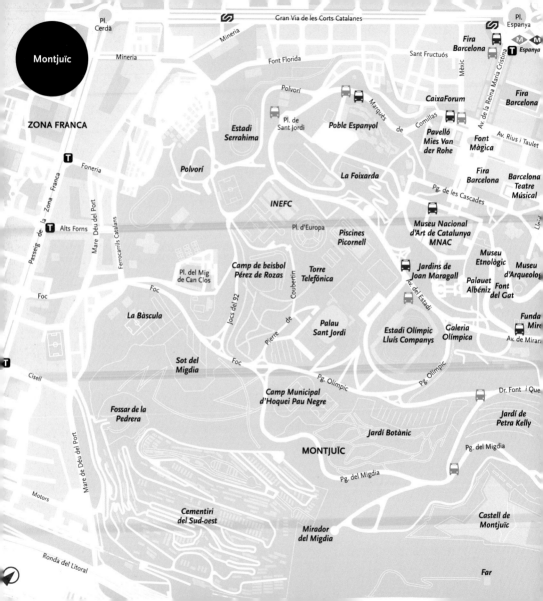

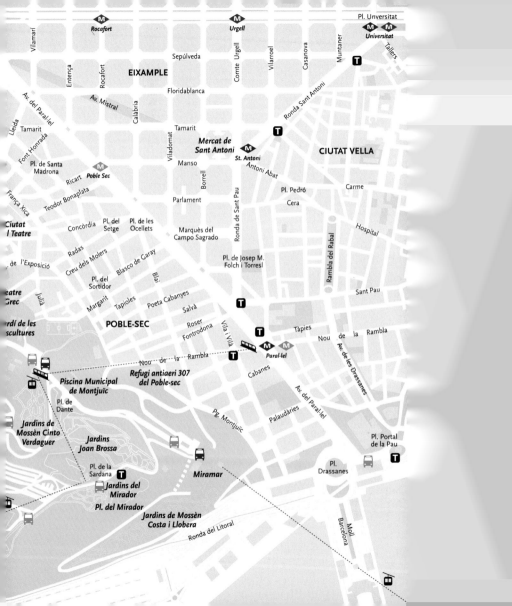

Montjuïc, the magic mountain.

As well as the trade fair and sporting use, which takes place in the 1929 halls and the 1992 installations, culture and leisure are the two main activities on offer in Montjuïc. The mountain possesses some of the most interesting museums in the city, such as the National Museum of Art of Catalonia (MNAC), the Fundació Joan Miró or the CaixaForum, which we will give a special emphasis to on the following pages. There are others too, however, such as the Ethnological Museum, the Archaeological Museum or the Fundació Fran Daurel. The theatre has several venues around the area, starting with the Grec, an amphitheatre of classical style, in the open air and where Barcelona celebrates its summer culture festival; next come the Teatre Lliure or the Mercat de les Flors, spaces for contemporary stage arts, with special emphasis on the sphere of drama and dance. Music, particularly popular music aimed at a mass audience, often finds its home in the Poble Espan-

Palau Nacional
The home of the MNAC is the most characteristic building of Montjuïc, along with the castle and the Olympic buildings

Font del Gat
Piece of cast iron in the heart of the Laribal Gardens

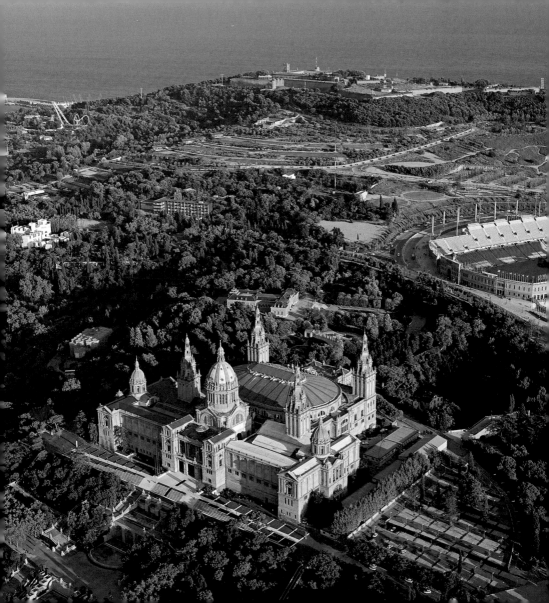

yol, the Olympic stadium, the Palau Sant Jordi or the Sot del Migdia space. These meetings of the masses experience their noisiest explosion at the end of September, when the end-of-summer popular festival of the Mercè is held, bringing together tens of thousands of people beneath the starry sky, and also lit up by the fireworks, the beams of light that crown the Palau Nacional and the play of lights of the magic fountain... Whoever is looking for peace and quiet will also find it in Montjuïc, higher up, where the architect Carlos Ferrater has designed a Botanical Garden following the logic of fractal waters. Higher up at the top of the mountain is the Montjuïc castle, a wonderful viewpoint over the waters of the port, with the Costa i Llobera gardens below you.

Venetian towers
The form the entrance portico to the Montjuïc trade fair precinct, made up of many pavilions

Magic Fountain
Work of the engineer Carles Buigas, this fountain offers a unique spectacle of light and water

Plaça d'Espanya
Overlooked by a huge fountain, work of Jujol, Plaça de Espanya contains buildings of different styles

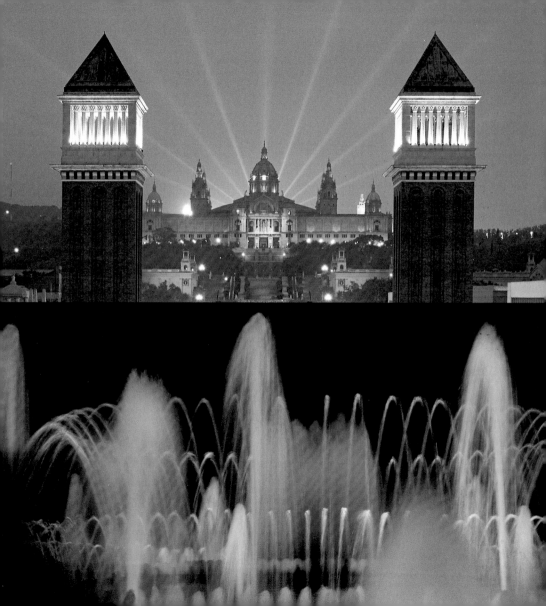

Museu Nacional d'Art de Catalunya

The MNAC is the flagship of Catalan art. From its majestic home in the Palau Nacional, high up Montjuïc, it offers a millennial tour of creative expression. Its collection of Romanesque mural painting is unique in the world: it was assembled at the beginning of the 20th century by means of a carefully organised rescue programme carried out on dozens of Pyrenean churches. Also of great interest is its collection of Gothic art, followed by a historical overview that is extended through to the 20th century, complemented by a programme of temporary exhibitions. The Palau Nacional has the oval hall, a very large space.

Palau Nacional
Parc de Montjuïc
Tel. 93 622 03 76
www.mnac.cat

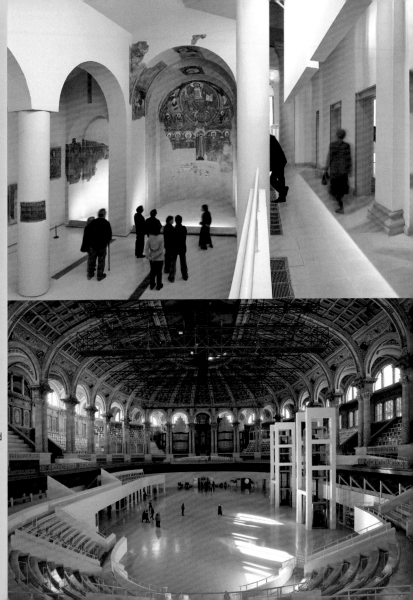

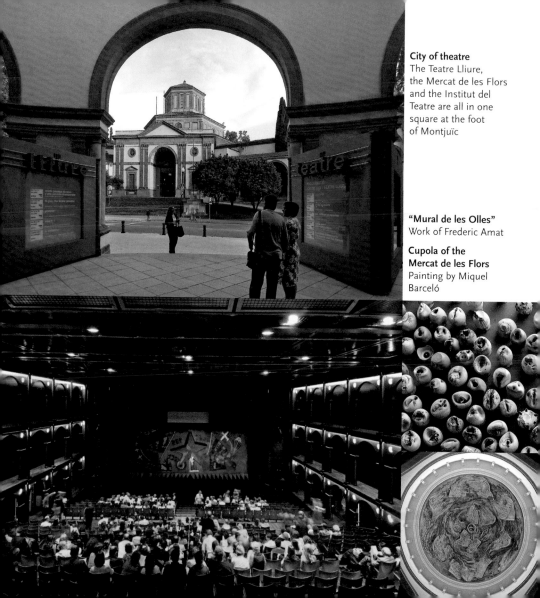

City of theatre
The Teatre Lliure,
the Mercat de les Flors
and the Institut del
Teatre are all in one
square at the foot
of Montjuïc

"Mural de les Olles"
Work of Frederic Amat

**Cupola of the
Mercat de les Flors**
Painting by Miquel
Barceló

Mies van der Rohe Pavilion
The German architect built this work in Barcelona in 1929, considered as a manifesto for modern architecture

„Morgen"
de Georg Kolbe

Mechanical escalators
One of the many mechanical escalators that help you climb up Montjuïc

←

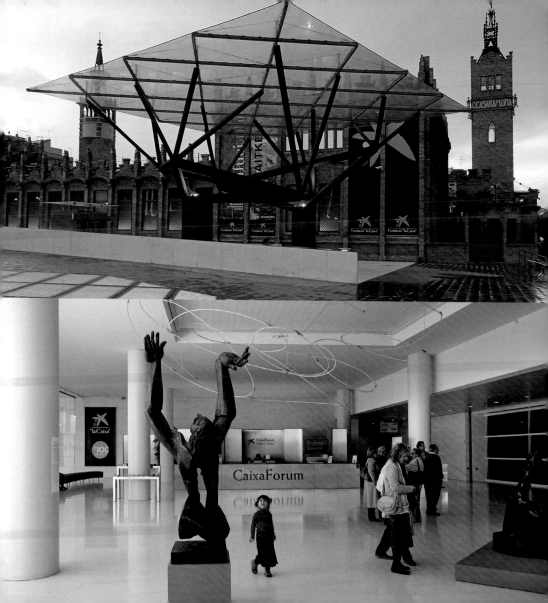

CaixaForum

CaixaForum is one of the more recent additions to Barcelona's list of museums. This exhibition centre promoted by the Fundació "la Caixa" is located in the old Casaramona factory, one of the main examples of industrial Modernism, designed by Puig i Cadafalch, now fitted out for its new cultural uses. CaixaForum, situated opposite the German pavilion in the Exhibition of 1929, work of Mies van der Rohe, organises and houses distinct artistic, musical and literary activities on a regular basis. Open Tuesday to Sunday, from 10 a.m. to 8 p.m. Free entry.

Av. Marquès de Comillas, 6-8
Tel. 93 476 86 00
www.lacaixa.es/obrasocial

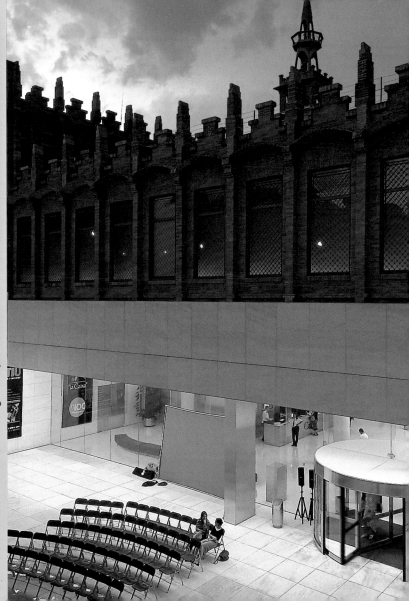

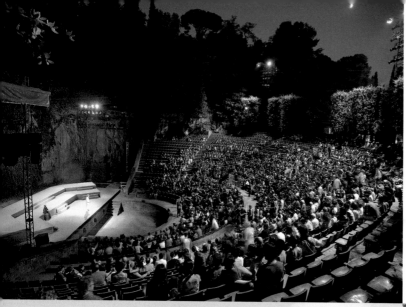

Teatre Grec
When summer comes, Barcelona inaugurates its theatre festival, which takes place in the open air in the Teatre Grec

"The three Graces"

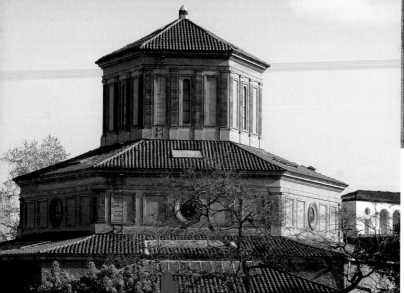

Archaeological Museum
Its Iberian, Greek, Carthaginian and Roman collections are kept in a building of Florentine style

El Poble Espanyol

The *Poble Espanyol*, or Spanish village, is a museum of popular Spanish architecture, built specifically for the International Exhibition of 1929, where 117 buildings, streets and squares from different Spanish regions were built, carefully assembled in an area measuring almost 50,000 square metres. This work, backed by Puig i Cadafalch, led by the critic Utrillo and the painter Nogués, and designed by the architects Folguera and Reventós, was built without any eye on the future, but has stood there until today.

Av. Marquès de Comillas, 13
Tel. 93 508 63 00
www.poble-espanyol. com

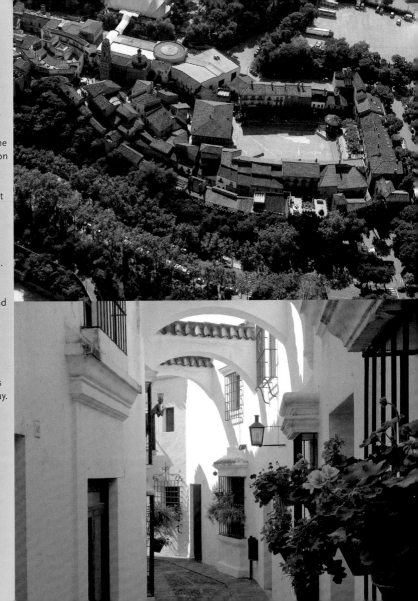

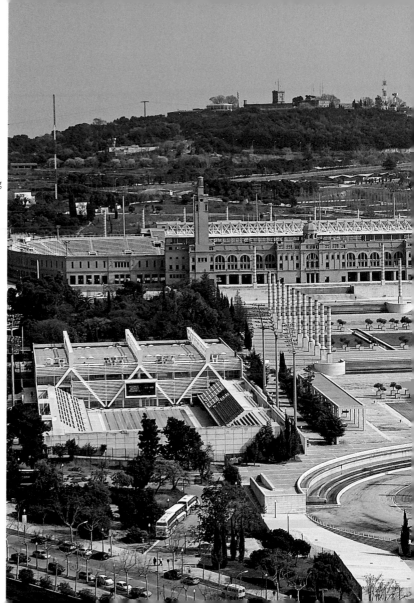

Olympic Ring
The main setting for
the 1992 Olympic
Games, designed
by Buxadé/Correa/
Margarit/Milà, brings
together, among other
constructions, the
Olympic Stadium
–in the background–;
the Picornell Swimming
Pools –on the left–;
Palau Sant Jordi; and
the Torre Telefónica
by Santiago Calatrava,
next to the Plaça
d'Europa

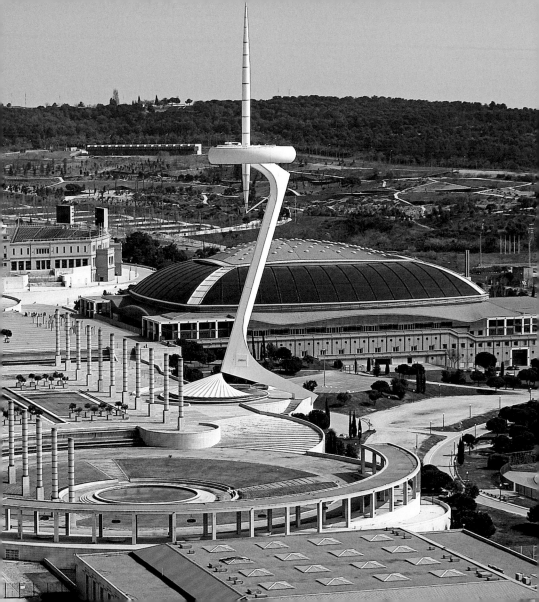

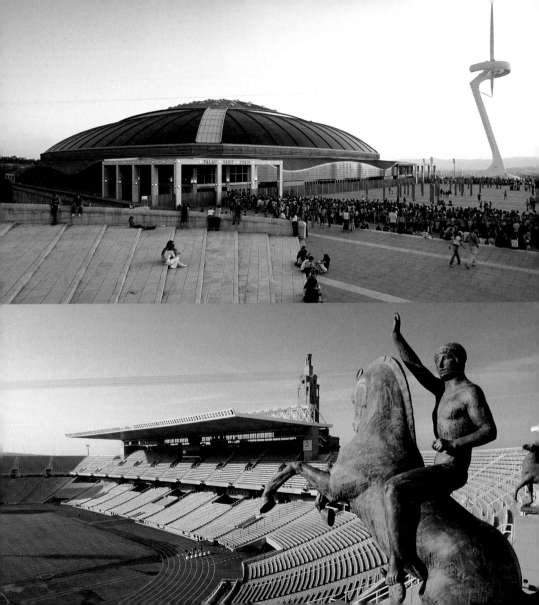

Palau Sant Jordi
Work of the Japanese Arata Isozaki, it is the large covered installation of the Olympic Ring

Olympic Stadium
Reconstructed by Correa/Milà/Gregotti, it was the main venue for the 1992 Olympics

Picornell Pools
Fernández/Gallego remodelled these swimming pools for the 1992 Olympics

Olympic censer

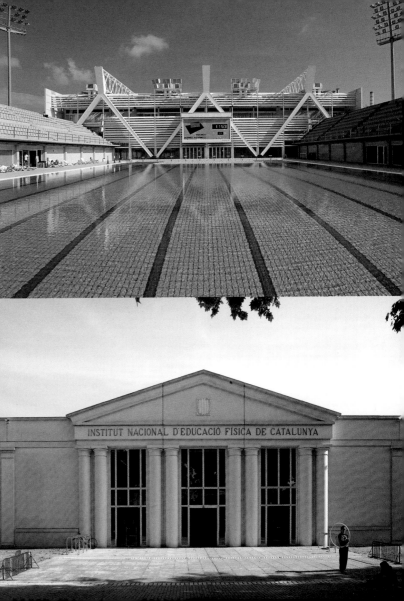

INEFC
A neo-classical building by Ricardo Bofill houses the headquarters of the physical education school

Botanical Gardens
At the top of Montjuïc, Carlos Ferrater has designed a new garden whose layout is inspired by fractal theory

Albéniz small palace
Built by Juan Moya, behind the National Museum of Art of Catalonia, in 1929

"Saint George", by Josep Llimona

Ethnology Museum
This view into other civilisations contains thousands of items from South America, Africa and Asia

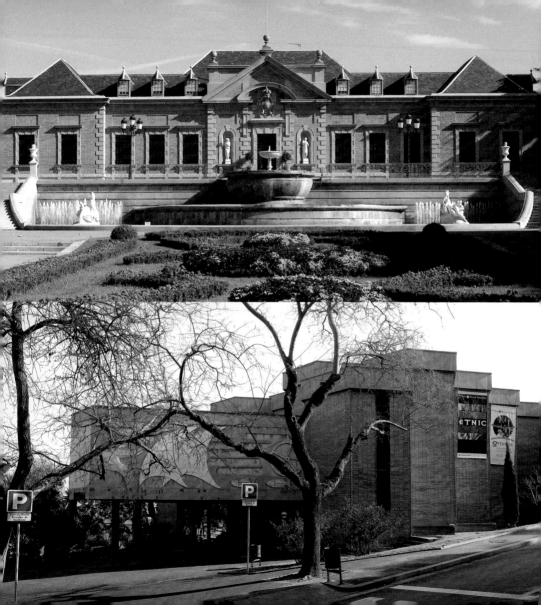

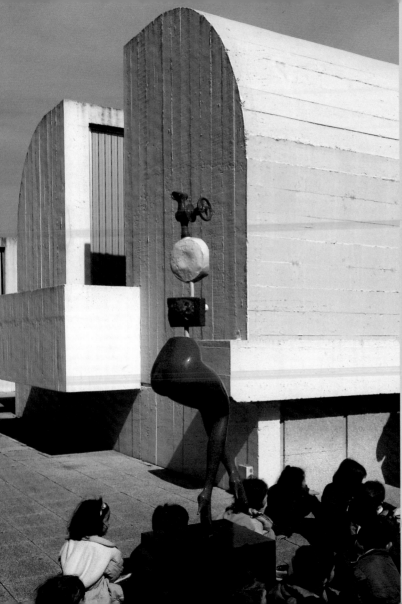

Fundació Joan Miró

Joan Miró, Barcelona painter and legendary figure of surrealism, brought about the creation of the foundation that bears his name, with two main objectives: to conserve and exhibit a very important part of his work and to stimulate the work of young artists. Situated in a building of Mediterranean style, built with clear concrete by the architect Josep Lluís Sert, the Fundació Miró is a well-lit centre, surrounded by trees and sculptures. The exhibition rooms show paintings, sculptures, tapestries and ceramics from all of Miró's periods, as well as temporary shows of other figures from contemporary art. It is open Tuesday to Saturday from 10 a.m. to 7 p.m. and Sundays from 10 a.m. to 2.30 p.m.

Parc de Montjuïc, s/n.
Tel. 93 443 94 70
www.bcn.fjmiro.cat

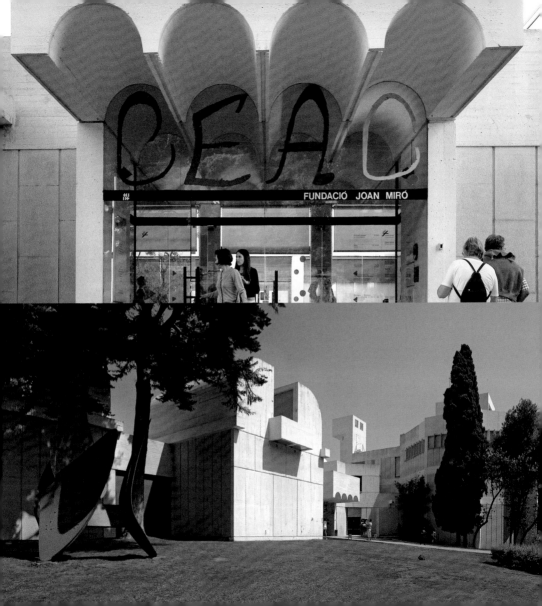

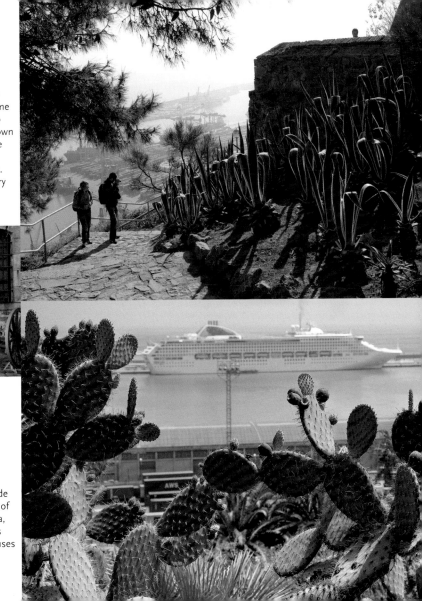

Montjuïc Castle
The first castle of Montjuïc, at the highest point of the mountain of the same name, dates back to the 17th century. Blown up and rebuilt in the 18th century, it is a star-shaped fortress. It houses the Military Museum

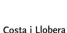

Costa i Llobera Gardens
On the mountainside with the best views of the port and the sea, Montjuïc possesses this garden of cactuses and fleshy plants

The Montjuïc Cable Car and Funicular
These two means of transport enable you to reach the peaks of Montjuïc with ease

"Mayor's Viewpoint"
This corner provides some of the best views in Barcelona over the city and the Mediterranean. Some parts of its pavement are the work of Joan Josep Tharrats

Sardana
The traditional Catalan dance has its monument in Montjuïc, a short distance from the castle

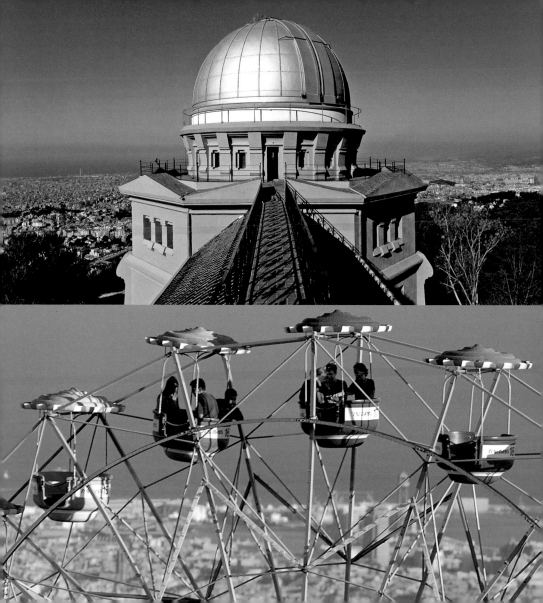

Collserola

Collserola Park is a forested area of 8,000 hectares. Situated between the Besós and Llobregat rivers, it shelters Barcelona, limits the city's growth inland and separates it from the Vallès county. Pine trees, holm oaks and oaks provide the green carpet of this first chain of hills on the coastline, and there are also areas of thicket and cultivated land. The fauna is that of a Mediterranean wood, and includes rabbits, wild boars and birds of prey. On the slopes facing Barcelona, Collserola forms a giant viewpoint over the city, with the Tibidabo Amusement Park, built in 1899 on the highest part of Collserola (512 m), providing a wonderful view. With a 360° panorama, you can take in the whole city and the sea as well as the Vallès area. Since 1992, the Collserola communications tower (268 metres high), designed by Norman Foster a short distance from Tibidabo, has had the highest viewpoint. A small part of Collserola has been urbanised, but since 1987 the park has been protected in order to conserve its natural resources, ecological balance and, at the same time, ensure it can be enjoyed to the full by the public. As well as Tibidabo and the communication tower, the park encompasses other facilities, ranging from the Fabra meteorology and astronomy observatory to several museums, such as that dedicated to the poet Verdaguer. They are attractions placed there by man, but if they weren't there, the people of Barcelona would still come to Collserola to get some fresh air, go for a walk and look out over the city.

Fabra Observatory
Hundred-year-old scientific installation dedicated to meteorological, astronomical and seismic studies

Tibidabo Amusement Park
A nostalgic setting for generation alter generation of Barcelona's inhabitants

Collserola.
At any time of year, even during the winter, the Barcelona locals make full use of their free time to go up to Collserola and go for a walk, cycle or ride a horse. The most typical route to the park is the one that the blue tram covers, a venerable system of public transport, started in 1901, which leaves from Plaça Kennedy. Half way on its route, the tram crosses the ring roads that surround Barcelona and passes by the higher part of the city on its borders with Collserola; in this strip is Vall d'Hebron, an Olympic centre, with interesting sculptures, such as the monumental "Matches" by Oldenburg... The blue tram ends its route close to the Carretera de las Aigües —a splendid more or less level pathway that embraces the entire Barcelona side of Collserola half way up— and after the tram you can change onto a funicular rack train that climbs up to Tibidabo Amusement Park. This park, overlooked by a large church dedicated to the Sacred Heart, has 30 attractions, spread around its 70,000 square metres of space

Blue Tram
Since 1901, it has taken the people of Barcelona to the Tibidabo Amusement Park

Velodrome Gardens
Sculpture by Joan Brossa outside the velodrome

Collserola Tower
The slender telecommunications building, work of Sir Norman Foster

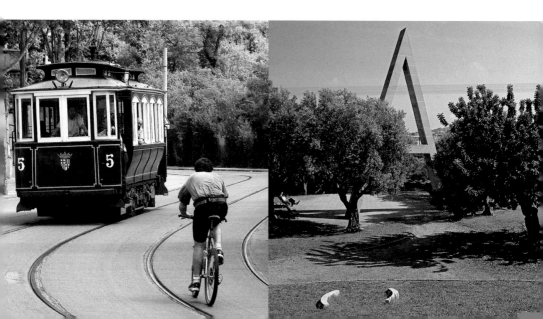

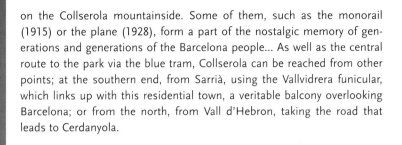

on the Collserola mountainside. Some of them, such as the monorail (1915) or the plane (1928), form a part of the nostalgic memory of generations and generations of the Barcelona people... As well as the central route to the park via the blue tram, Collserola can be reached from other points; at the southern end, from Sarrià, using the Vallvidrera funicular, which links up with this residential town, a veritable balcony overlooking Barcelona; or from the north, from Vall d'Hebron, taking the road that leads to Cerdanyola.

"Matches", by Claes Oldenburg

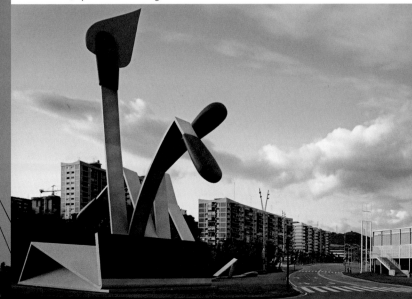

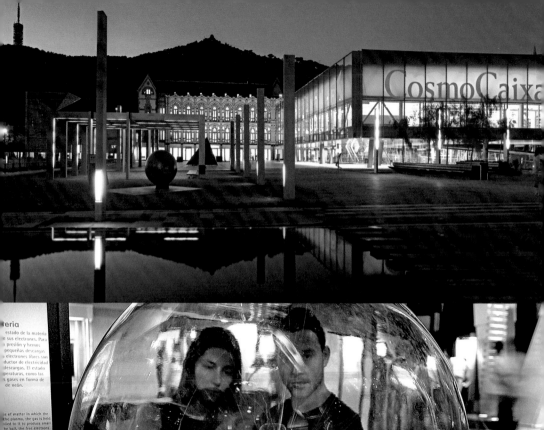

CosmoCaixa

Barcelona's large science museum is called CosmoCaixa and is on the Collserola mountainside. It has lots of different installations, among which feature, due to its spectacular appearance, a flooded Amazonian forest (where the animal and jungle plant world is reproduced), a geological wall, a planetarium and the so-called "matter room". CosmoCaixa is open from Tuesday to Sunday from 10 a.m. to 8 p.m.

Teodor Roviralta, 47-51
Tel. 93 212 60 50
www.cosmocaixa.com

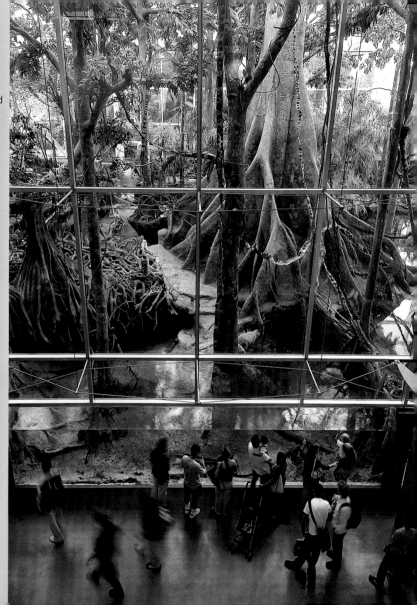

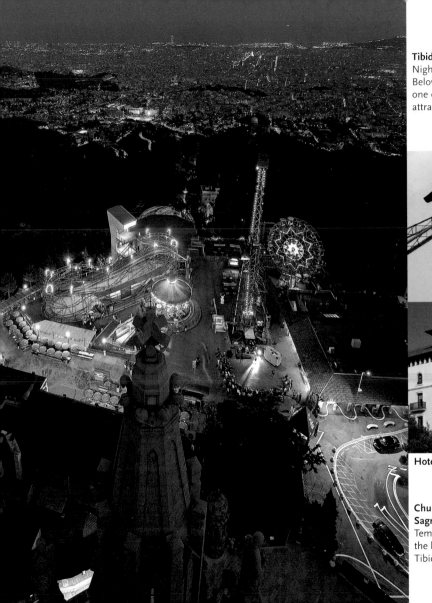

Tibidabo Park
Night view of the park. Below, the aeroplane, one of its symbolic attractions

Hotel La Florida

Church of the Sagrat Cor
Temple situated at the highest point of Tibidabo Park

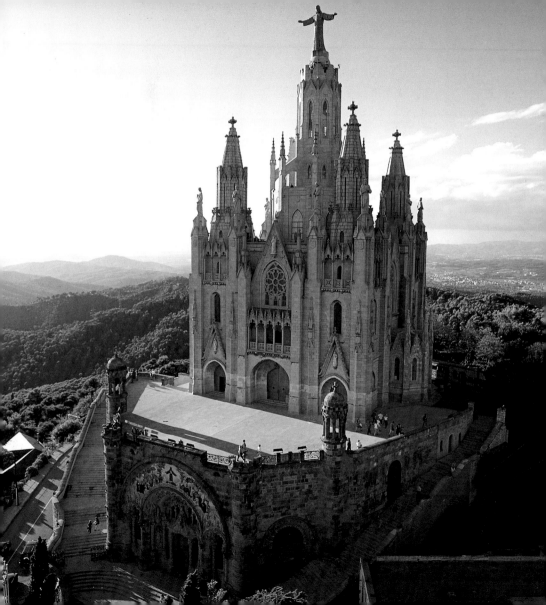

Contemporary architecture

Barcelona —the city of Gaudí— and architecture have a long-lasting love affair going, which continues to provide attractive results. Among the most recent, speaking now of the 21st century, we should mention the Agbar Tower, a circular ground plan construction and tapering shape, whose changing multicolour skin provides a spectacular light show at night. The tower was designed by the French architect Jean Nouvel. Another no less colourful work is the reform of Santa Caterina, in the heart of the old quarter; Miralles/Tagliabue crowned this market with an undulating ceramic roof, where all the shades shines out in a still life of fruit and vegetables. The same authors were responsible for the new offices of Gas Natural, half way between Barceloneta and the Olympic Village, a building of broken down volumes.

International and local architects have contributed to this constant renovation, begun at the dawn of the modern era by Mies van der Rohe (with his German Pavilion in 1929) or Sert, a renovation that has ended up by defining new areas of the city. This is the case of the area where the Forum 2004 was held, with constructions such as the Forum Building, by Herzog and De Meuron, with its triangular volume; or the massive International Convention Centre of Barcelona, work of Josep Lluís Mateo; or the impressive photovoltaic plaque by Torres/Lapeña. This also applies to the Olympic Village, a district planned by the best Catalan architects in the second half of the 20th century, crowned by two skyscrapers and with works by Siza and Gehry... These are not the only examples of contemporary architecture of interest in Barcelona... and nor will they be the last.

Forum Building
Detail of the covering
of the Forum Building,
work of Herzog &
de Meuron

Santa Caterina Market
Detail of the ceramic
and multicolour roof
of this work by Miralles
and Tagliabue

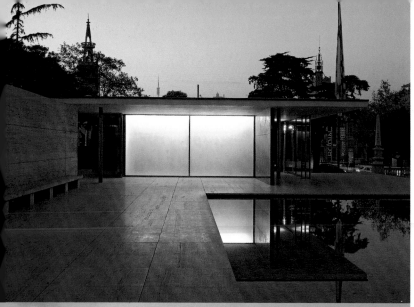

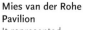

Mies van der Rohe Pavilion
It represented Germany in the International Exhibition of 1929

Pavilion of the Republic
Work of Sert and Lacasa, it represented Spain in Paris in 1937 and was rebuilt in Barcelona

Fundació Miró
Excellent example of the Mediterranean architecture of Sert, it houses part of the Miró legacy

Houses in Muntaner/Ubach
One of the founding works of Barcelona rationalism, the work of Sert

Roca Jewellers
Another work by Josep Lluís Sert, it is in Passeig de Gràcia, on the corner with Gran Via

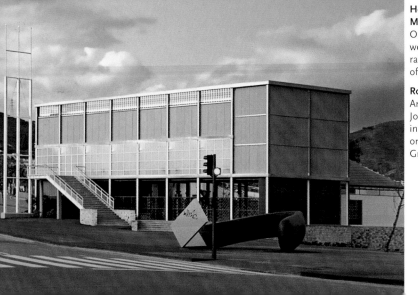

Trade Buildings
Four black, glass towers with undulating perimeter, the work of Coderch de Sentmenat

Faculty of Architecture
The extension of this university centre was the last work of Coderch de Sentmenat

BancSabadell
Where the streets of Balmes and Diagonal meet, Francesc Mitjans built this tower block of 20 storeys

Colón Tower
Skyscraper completed in 1971 very close to the Columbus monument, at the seafront end of the Rambla

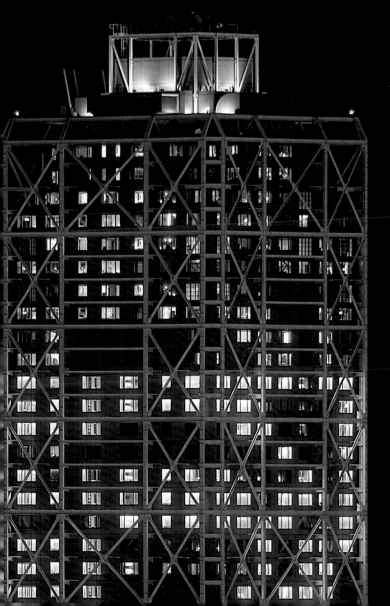

Hotel Arts
One of the two tall towers of the Olympic Village, work of Bruce Graham (Skidmore, Owings and Merrill)

Collserola communication tower
Sir Norman Foster designed this spectacular construction that overlooks Barcelona

Torre Telefónica
This company commissioned their own communication tower to Santiago Calatrava, in the Olympic Ring of Montjuïc

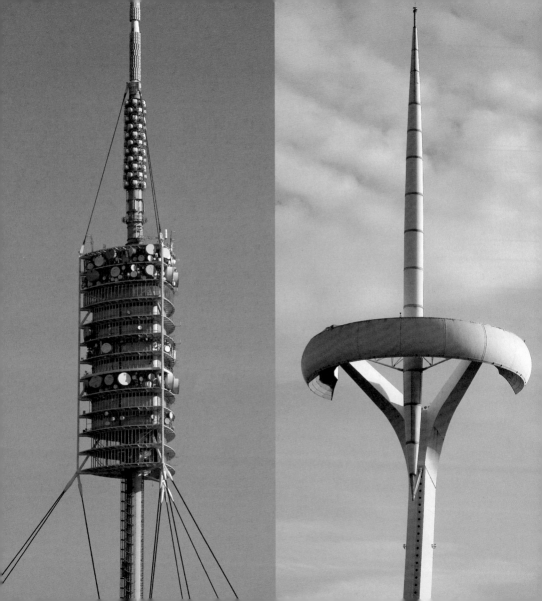

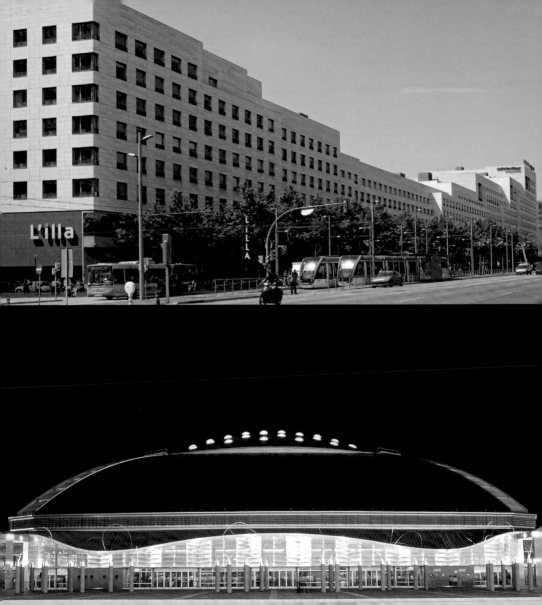

L'Illa Diagonal
It is known as the "sideways skyscraper", and carries the signature of Rafael Moneo and Manuel de Solà-Morales

Palau Sant Jordi
The roof of this Olympic venue, work of Arata Isozaki, reminds one of a tortoiseshell

"Fish"
Frank Gehry designed this spectacular fish for the garden of the Hotel Arts, before the Guggenheim Museum of Bilbao

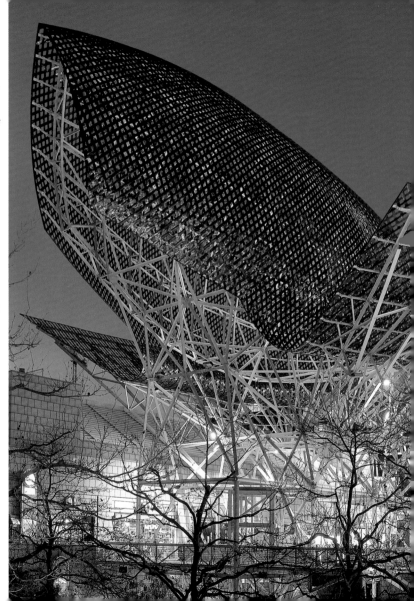

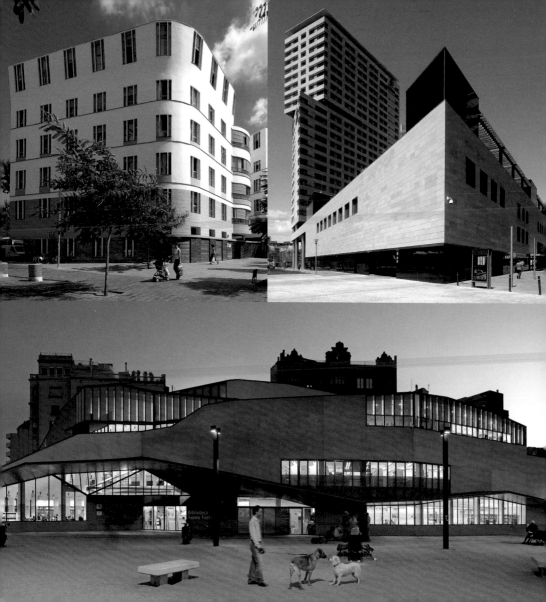

Fort Pienc
Detail of the small community centre built by Josep Antoni Llinàs in Fort Pienc

Hilton Diagonal Mar
Designed by Óscar Tusquets in the Forum Area

Jaume Fuster Library
Another outstanding work by Josep Antoni Llinàs, it is situated in Plaça Lesseps

World Trade Center
Alongside the port and the sea, Henry Cobb built this powerful office building

El Corte Inglés
The department store commissioned Lapeña/Torres and MBM with its façades in Plaça de Catalunya

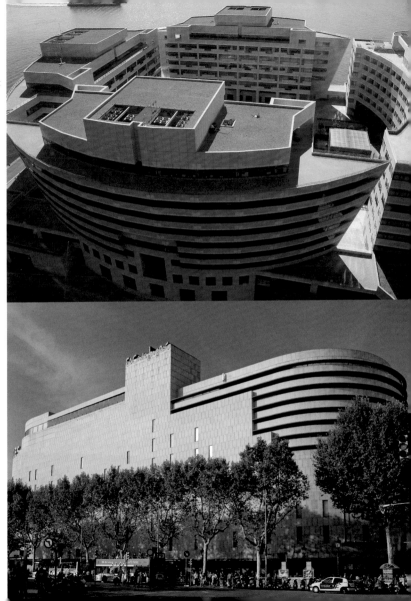

Forum Building
Triangular building, with a rough, blue exterior, by Herzog & de Meuron

International Convention Centre of Barcelona
Work of J. L. Mateo

Photovoltaic plaque
Construction by Lapeña/Torres in the Forum esplanade

Hotel Princess Barcelona
Work by O. Tusquets

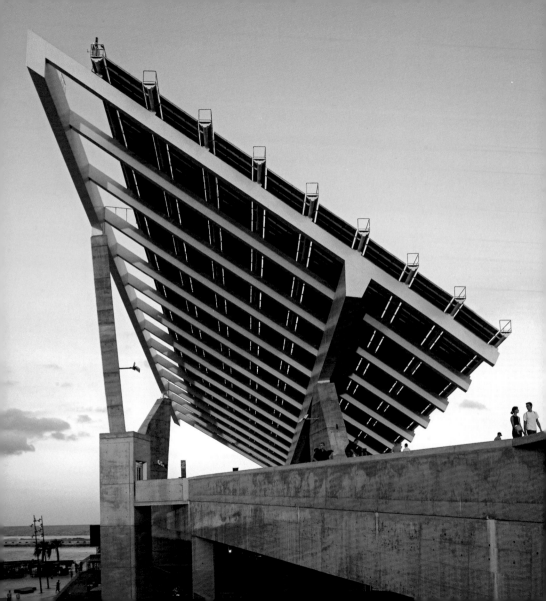

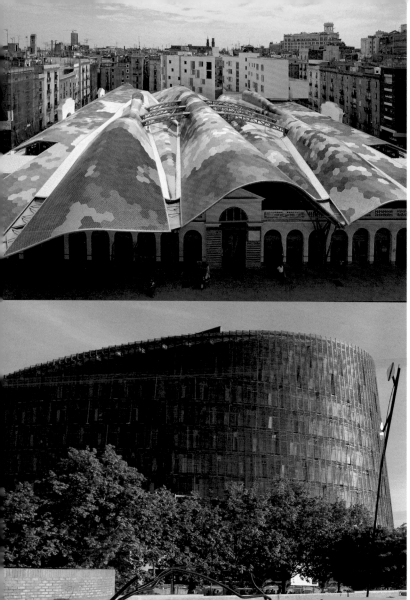

Santa Caterina market
With its spectacular ceramic roof. It is the work of Miralles and Tagliabue

Barcelona Biomedical Research Park
Work of Manuel Brullet, covered with wood, facing the sea

Marenostrum Tower
Skyscraper in several sections designed by Miralles and Tagliabue

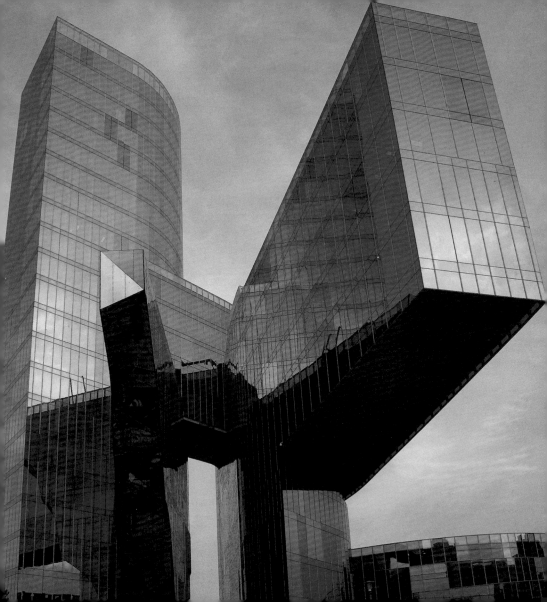

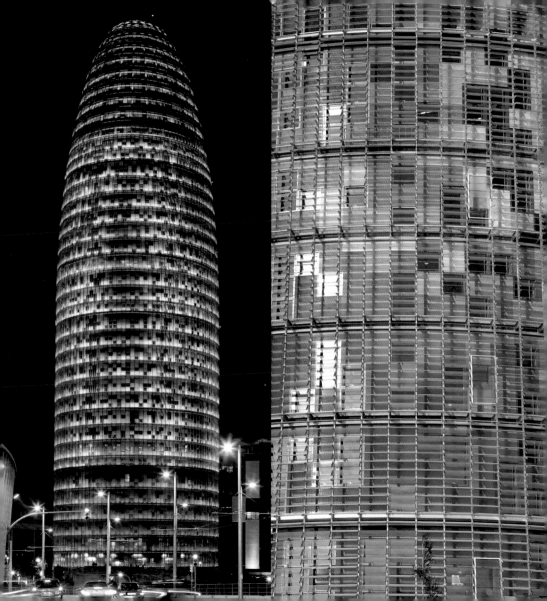

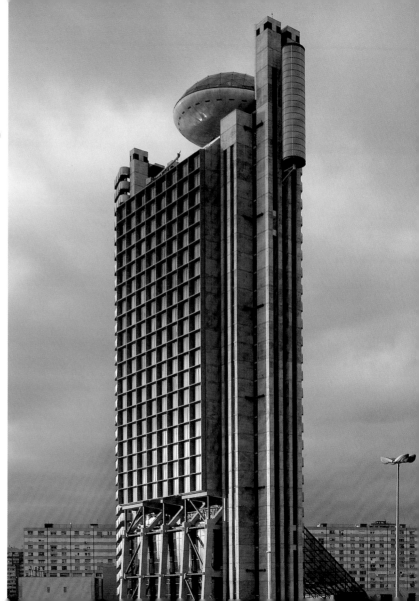

Agbar Tower
Jean Nouvel has designed one of the buildings that is symbolic of the new Barcelona, in a tapering form and with a changing night-time colouring

Hotel Hesperia Tower
On the way to the airport of Barcelona stands this tower designed by Richard Rogers

Audiovisual Campus
Construction planned by David Chipperfield.

Details of the Torres Fira in Hospitalet and of the Fira de Barcelona Gran Vía
Works by Toyo Ito.

Terminal T1 of Barcelona airport
Designed by Ricardo Bofill.

UPF Campus
Project by Ramon Valls and Josep Benedito in District 22@.

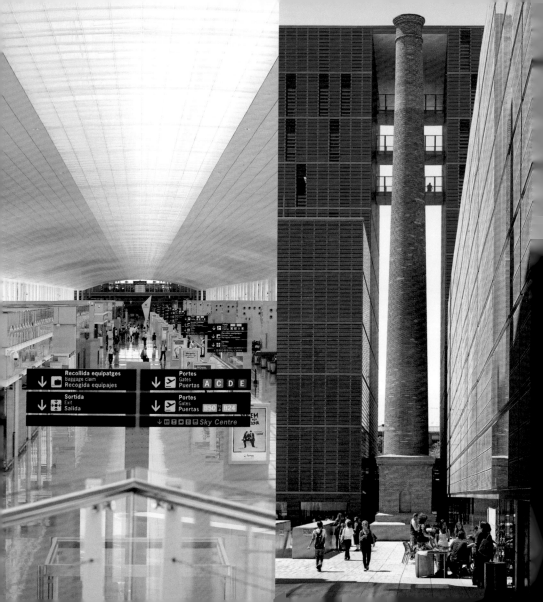

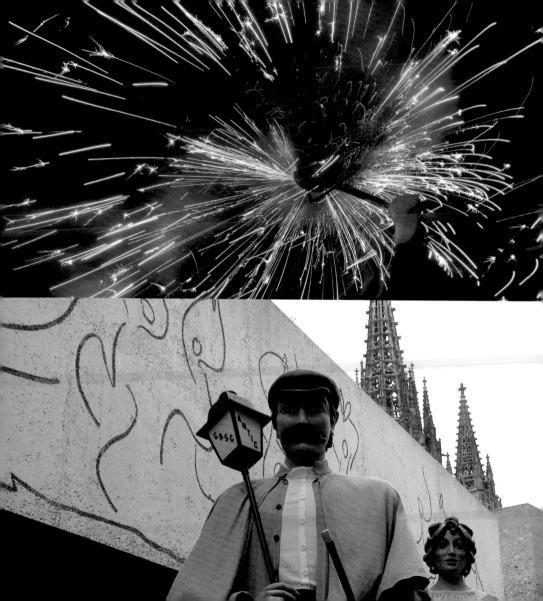

Festivals

Barcelona is a city that boasts the presence innumerable street festivals. Barcelona's culture of local associations and participation, accompanied by the Mediterranean climate, has been a key to this culture. Some festivals, such as the *Correfoc* (firework processions), date back to ancestral customs, to pagan rites related to the sun and fire. Others, such as those featuring "giants" and "bigheads", are rooted in the history and tradition of local society. The *castells* —human towers— and the *sardanes* —the typical Catalan dance, which is danced holding hands in a circle— reflect diligence, method, a spirit of cooperation and concordance. The local summer festivals are an excuse for everyone to let their hair down and just have lots of fun. In Barcelona there are street festivals all year round, starting with the Cavalcade of the Three Kings of the Orient (5th January) and Carnival (February), followed by Saint Eulàlia (12th February) or Saint George (23rd April, with its spectacular show of books and roses). It is in the second fortnight of September, however, when Barcelona has its own citywide annual festival —the festivals of the Mercè— dedicated to the patron saint: a popular explosion of colour with a Mediterranean flavour, during which there are passacaglia, free open-air concerts and a fantastic firework display to music that lights up the Barcelona night with sound and colour... Added to these festivals, with traditional roots and a Barcelona air, have arrived others of a newer type and with a more global base, such as the Sonar festival of advanced music, thus guaranteeing the future and projection of the city's festive spirit.

Festivals of the Mercè
Fireworks and giants,
two typical aspects
of Barcelona's annual
festival

Bestiary
Lions, birds of prey, donkeys, bulls, parrots... different expressions of Barcelona's festive bestiary

Bigheads
The *capgros* –bighead– is the regular companion of the giants in the festival parades

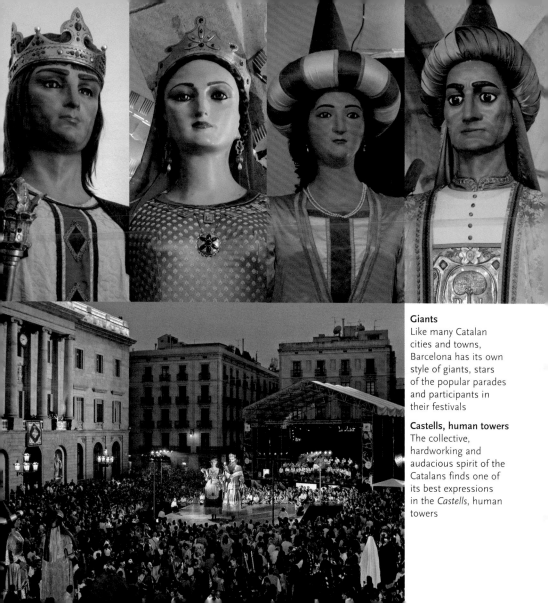

Giants
Like many Catalan cities and towns, Barcelona has its own style of giants, stars of the popular parades and participants in their festivals

Castells, human towers
The collective, hardworking and audacious spirit of the Catalans finds one of its best expressions in the *Castells*, human towers

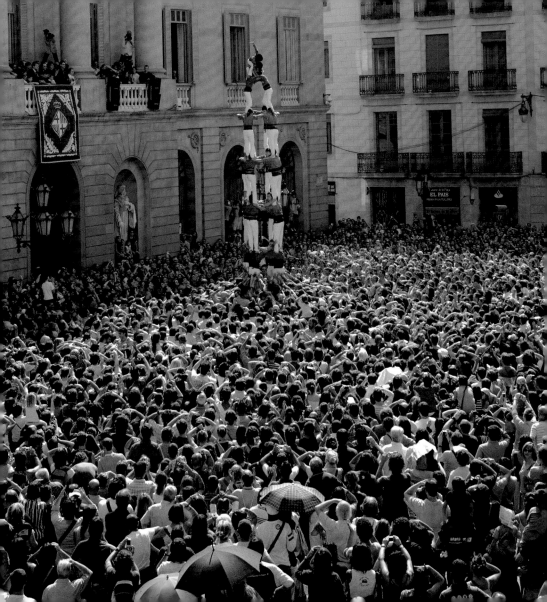

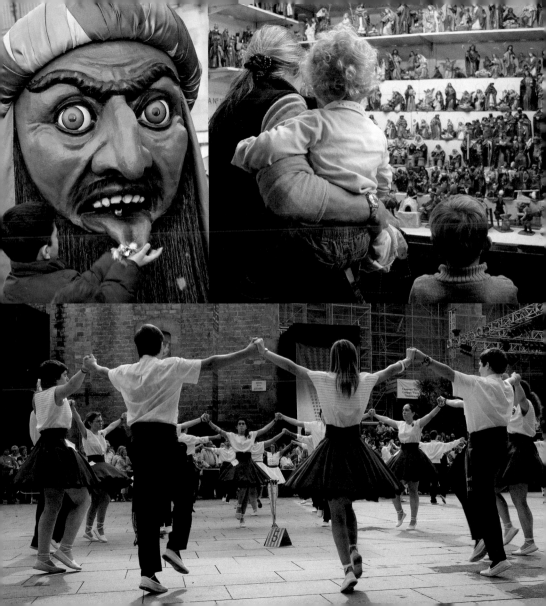

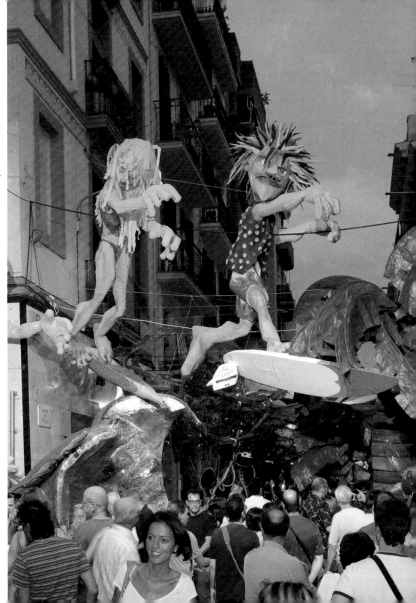

Fair of Saint Lucy
In the days leading up to Christmas, the area surrounding the cathedral is the venue for the Fair of Saint Lucy

Sardana event
The typical Catalan dance is highly popular on public holidays in Plaça de la Catedral

Festivals of Gràcia
In the first half of August, Gràcia dresses up its streets to celebrate the popular annual festivals

Following double-page

Correfoc
Fireworks and traditions are central elements in the *Correfoc* (running fireworks) street festivals

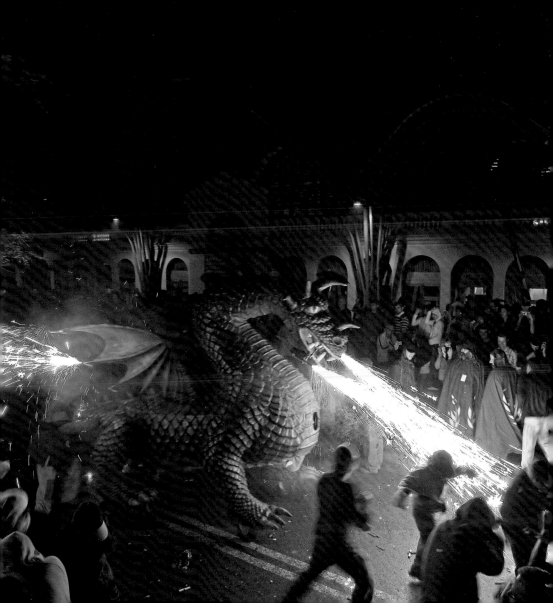

Edition by
Triangle Postals SL

Text
© Llàtzer Moix

Photography
© Pere Vivas
© Ricard Pla (p. 25, 27, 37, 48a, 49, 51, 64f, 66, 72d, 101, 142a, 225, 228bc, 232b, 233, 236ab); Biel Puig (p. 36, 39, 50e, 61, 72b, 107a, 172, 188b, 200b, 229a); Joan Colomer (p. 194b, 195a, 197a, 200a, 201); Jordi Puig (p. 170d); Caterina Barjau (p. 70bc); Juanjo Puente/ Pere Vivas (p. 74b, 117c); Juanjo Puente (p. 89); Mercè Camerino (p. 230b); Antonio Martínez (p. 237); Aina Pla (p. 64d); Ramon Pla (p. 50b); Jordi Todó (p. 173a)
© Casa Batlló/P. Vivas/R. Pla (p. 96, 97, 98, 99, 100, 101)
© P. Vivas / Junta Constructora del Temple de la Sagrada Família (p. 108, 109, 110, 111, 112, 113)

Art Direction
Ricard Pla

Design
Joan Colomer

Layout
Mercè Camerino, Aina Pla

Translation
Steve Cedar

Production
Imma Planas

Printed by
Sanvergráfic
9-2009

Registration number
B-50006-2007

ISBN
978-84-8478-316-9

Triangle Postals SL
Pere Tudurí, 8
07710 Sant Lluís, Menorca
Tel. 34 971 15 04 51
Fax 34 971 15 18 36
www.triangle.cat
triangle@triangle.cat

Acknowledgements:
Ajuntament de Barcelona
Biblioteca de Catalunya
Cambra de Comerç, de la Indústria i de Navegació de Barcelona
Casa Àsia
Casa Amatller
Centre de Cultura Contemporània de Barcelona
Col·legi de les Teresianes
Consorci de la Colònia Güell
Diputació de Barcelona
Família Herrero, Casa Vicens
Fundació Antoni Tàpies
Fundació Caixa Catalunya
Fundació Joan Miró
Fundació "la Caixa"
Fundació Mies van der Rohe
Generalitat de Catalunya
Gran Teatre del Liceu
Herboristeria del Rei
Hospital de la Santa Creu i de Sant Pau
L'Auditori
Museu Barbier-Müller
Museu d'Art Contemporani de Barcelona
Museu d'Història de Catalunya
Museu d'Història de Barcelona
Museu Egipci
Museu Marítim
Museu Nacional d'Art de Catalunya
Museu Picasso de Barcelona
Palau de la Música Catalana
Teatre Nacional de Catalunya